HYTHE
THROUGH TIME
Martin Easdown
& Linda Sage

AMBERLEY PUBLISHING

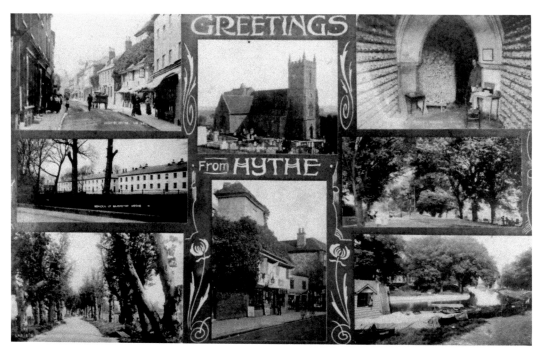

A multi-view postcard dating from 1906 showing the main features of Hythe at that time, most of which still remain. From the top middle, clockwise, the pictures show the Parish Church of St Leonard, the skulls in the crypt of the church, the Grove, Royal Military Canal, Smugglers Retreat (demolished 1907), Ladies Walk, School of Musketry (demolished 1970s) and the High Street.

First published 2010

Amberley Publishing Plc
Cirencester Road, Chalford,
Stroud, Gloucestershire, GL6 8PE

www.amberley-books.com

Copyright © Martin Easdown & Linda Sage, 2010

The right of Martin Easdown & Linda Sage to
be identified as the Authors of this work has
been asserted in accordance with the Copyrights,
Designs and Patents Act 1988.

ISBN 978 1 84868 919 0

British Library Cataloguing in Publication Data.
A catalogue record for this book is available from
the British Library.

Typeset in 9.5pt on 12pt Celeste.
Typesetting by Amberley Publishing.
Printed in the UK.

Introduction

Hythe through time has had to alter and change like all settlements, but unlike many, it has managed to retain its charm as a small English town steeped in history. The purpose of this book is to show some of these changes, whether good or bad, through an interesting selection of past views of Hythe and its eastern suburb of Seabrook, along with (usually) a modern comparison photograph. The majority of the old photographs are previously unpublished, and we have avoided selecting many of Hythe's more popularly photographed views, seen numerous times before, in favour of scenes that are rare or unusual. A photograph is a moment in time, a unique, one-off snapshot that becomes a historical document as soon as one takes it, and the modern scenes shown in this book will themselves see changes in the years ahead. So as well as this book being a record of 'Hythe Through Time', this book is also a depiction of the town in the year 2010.

Hythe means 'haven', and its situation on the south-east coast of Kent, just 25 miles or so from France, has led it to be in the vanguard for defence of this vulnerable corner of England. Just outside the town can still be seen the remains of Stutfall Castle, part of the Roman Portus Lemanis. Hythe is one of the famous Cinque Ports: that group of seven coastal towns in Kent and East Sussex that were given their own rights and laws in medieval times, in exchange for, in the service of the monarch, providing a robust defence against foreign enemies and ships, as well as ensuring his safe passage across the English Channel. The town still possesses its charter, granted by Edward I in 1278 (along with many fourteenth-century documents of historical significance), and its importance in those times is demonstrated by its impressive Norman church and range of medieval buildings.

However, Hythe hit upon hard times during the fourteenth and fifteenth centuries. The town was attacked by the French and was ravaged by the Black Death in 1348-49, and then, in 1400, lost most of its fleet during a storm, many of its buildings by a fire, and the plague returned. Worse still, the port began to silt up and was unable to keep to its commitment of supplying ships to the monarch. Yet Hythe retained some measure of importance and, in 1575, was granted a Charter of Incorporation by Elizabeth I, which enabled it to elect its own mayor and councillors and hold a fair. The town slumbered quietly for a time thereafter, acquiring some impressive Georgian buildings on the way and a classical-styled town hall in 1794. Influential families such as the Deedes and Tournays, who held the mayor's office forty-one times between them, held an exerting influence over Hythe between the mid-seventeenth century and early nineteenth century.

Hythe was brought back into the firing line with the threatened Napoleonic invasion in the first decade of the nineteenth century. As a result, the town acquired ten of the curious Martello defence towers and a section of the Royal Military Canal. Both the towers and gun points on the canal never fired a shot in anger (except perhaps against the active local smugglers!) but the sylvan beauty of the canal soon led it to become one of Hythe's greatest attractions. The School of Musketry (later the Small Arms School) also came to Hythe, and although that closed in the 1960s, the firing ranges remain in use for soldiers from nearby Shorncliffe Camp and ensure that, for now, the town still has a role to play in the defence of the realm.

Hythe's old-world charm as a Cinque Port and its position on the coast led to it becoming a popular, if modest, seaside resort. The first purpose-built amenity for visitors was an indoor bath house built in 1854, and the popularity of the resort increased with the opening of a station by the South Eastern Railway in 1874. The railway company helped to finance the building of a grand hotel (the Seabrook, later the Imperial) in 1880 and an extension of the promenade, although the development of the exclusive Seabrook Estate failed to take place. Marine Parade and West Parade were developed in the late 1870s and 1880s by the corporation in association with private companies (demolishing some of the redundant Martello towers in the process) and were sporadically developed with accommodation, although further development had to wait until the 1920s.

By the Edwardian period, Hythe was attracting visitors who preferred a less boisterous type of watering place, for there was no pier, amusement rides or pierrot shows on the beach to disturb the quiet seafront. The cumbersome bathing machines were giving way to bathing huts, and donkeys provided rides along the promenade. The height of Hythe seaside fashion were the fairs, fêtes and donkey derbies held in the grounds of the Imperial Hotel, which liked to claim Hythe had the lowest death rate in England! Away from the beach, there was the Venetian Fête and boating on the Royal Military Canal, the macabre collection of skulls and bones in the parish church crypt, the horse tram to Sandgate, tree-lined Ladies Walk, Hythe Cricket Week, the Hythe Town Band in the Grove Bandstand, concerts and a subscription library in the Institute, and the charm of the old town climbing up the hill from the High Street. The first cinema came to Hythe in 1911 with the opening of the Hythe Picture Palace. In addition to tourism and servicing the military, the town's industries included brewing, milling and fishing. All facets of Hythe life in those days (including some of its disasters, as seen in this book) were captured by local photographers and publishers of postcards such as Parson's Library, H.B. F&L and the *Hythe Reporter*. The range of cards they produced was quite astonishing, and ensured that the allure of Hythe during that golden age before the Great War was captured forever for posterity.

However, the aim of this book is not to dwell on the Edwardian period for the selection of 'then' photographs, but present a varied selection through the photographic age, for change is forever ongoing. Hythe continued to flourish as a resort during the interwar period, when it acquired the world-famous Romney, Hythe & Dymchurch Railway in 1927 and was promoted by the Southern Railway as the 'Pride of Kent'. Two convalescent homes opened in that period: the Christian Holiday Fellowship at Moyle Tower in 1923 and Philbeach for London Transport workers in 1924. They helped ensure that Hythe received a regular stream of visitors to enjoy its health-giving air. In 1937, Hythe gained an ultra-modern Art Deco cinema, the Ritz. Following the end of the Second World War, the resort was promoted as 'where the country meets the sea', but changing holiday patterns saw visitor numbers decline, although Hythe has managed to retain its two large hotels, the Imperial and Stade Court. The 'Brand New Age' of the 1960s and 1970s saw a number of changes in Hythe: the Mackeson Brewery and Small Arms School were closed and subsequently demolished and a number of buildings fell victim to road widening. Landmarks have come and gone, leaving just memories and old photographs such as those seen in this book. However, on the whole, Hythe escaped the large-scale redevelopment of many towns and remains a pleasant town both to visit and live in, with a fascinating past to explore.

The advent of digital photography allowed us the option of immediately discarding a modern comparison image if deemed unsuitable and taking another, a luxury not afforded to the photographers who took the older photographs in this book. Nevertheless, there were a number of difficulties encountered which meant an exact modern comparison photograph was not always possible. The photographers of old often used a camera with a wider-angle lens than is available on a digital camera. Housing developments and the planting of trees has meant that a subject seen clear as a bell on an old photograph is somewhat hidden in the modern view. In some cases, it was not possible to access the site of an earlier photograph due to it being on private land or under new houses, meaning the comparison view had to be taken from another angle. It also has to be admitted that a modern photograph can never really convey the charm of many of those scenes of a hundred years ago, showing a way of life that has been totally changed and usually lost forever. Road traffic, along with seemingly ever-present roadworks, encroaches on byways that a century ago were populated by only the infrequent horse and cart. Occasionally, where we felt a subject was of particular interest, we have sacrificed the modern view in favour of two older photographs.

We have enjoyed compiling this book of the town where we both live and hope that it captures some of the quintessential charm of Hythe, of then and now.

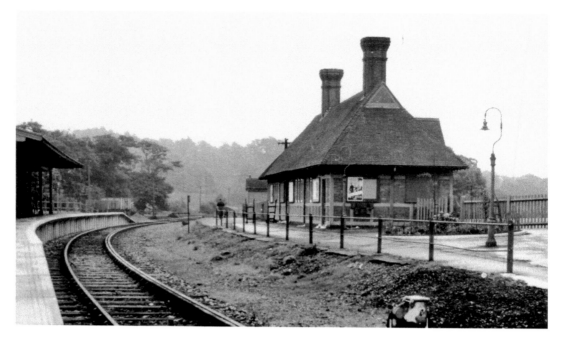

Sandling Junction Railway Station

The Hythe branch platform of Sandling Junction station in around 1950. Opened in 1874, with Sandling Junction added in 1888, the branch had been singled upon the closure of the Hythe to Sandgate section in 1931 and the up platform was taken out of use. The line was closed completely in 1951, and today's scene shows that the down platform remains and the track bed is overgrown.

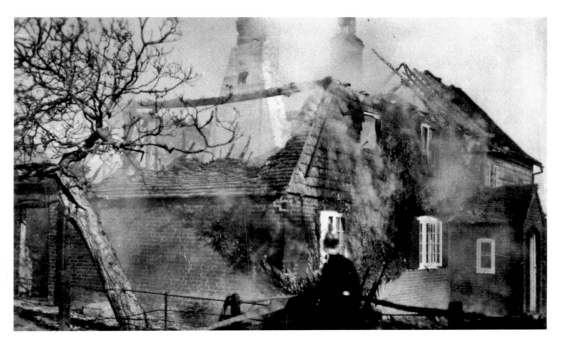

Dibgate Farmhouse Fire
A postcard by Parson's Library of Hythe showing the destructive blaze at Dibgate Farmhouse on 19 May 1914. The fire tragically claimed the life of Lionel Davison, who had caused it by smoking in bed. The farmhouse was not rebuilt, but in the 1960s, a house called Fox Lair was built on the site.

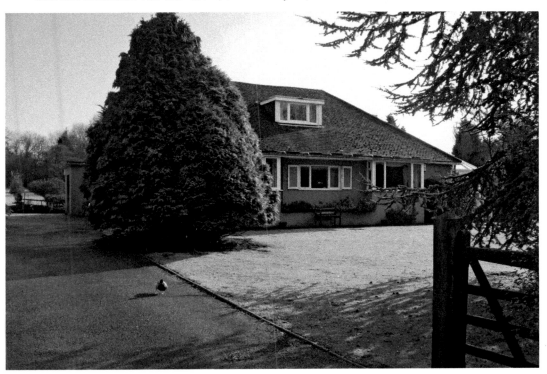

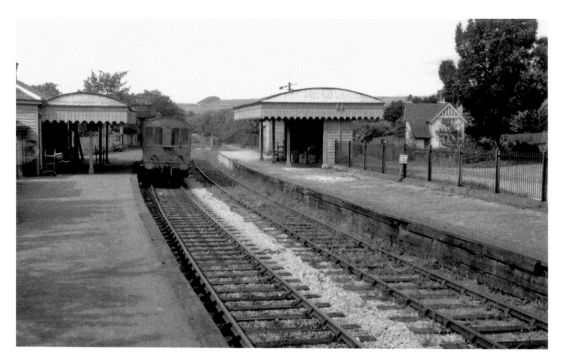

Hythe Railway Station

The station is seen photographed here on 25 August 1951, just a few months before it was closed on 1 December 1951. The station was erected in 1874 by the South Eastern Railway in its typical wooden clapboard style. On the right can be seen the stationmaster's house in Cliff Road. The site of the station is now completely covered in housing, but the stationmaster's house still remains.

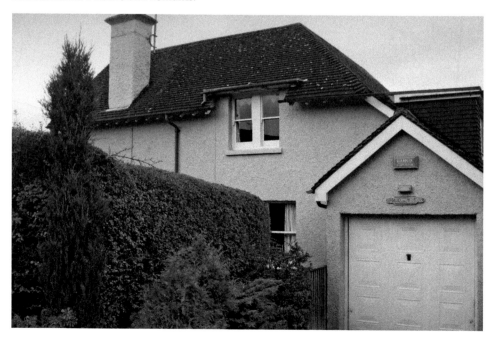

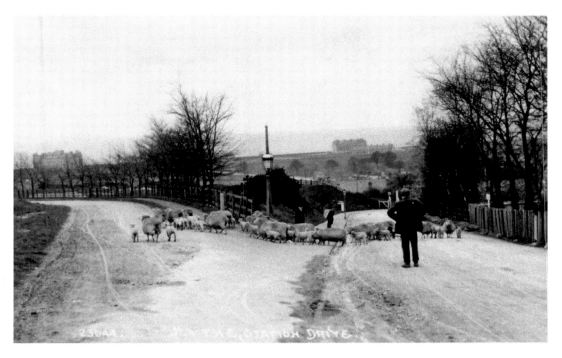

Junction of the Station Approach Road and Cannongate Road

A scene that has changed greatly since the top photograph was taken *c.* 1912 and the lower one in 2010. The Edwardian view was taken just below Hythe Station and shows the Station Approach Road going down the hill and Cannongate Road veering off to the left. The sheep may have been unloaded from a train. The modern view shows that the Station Approach Road has been completely obliterated by housing, although the southern end of the road is still in place.

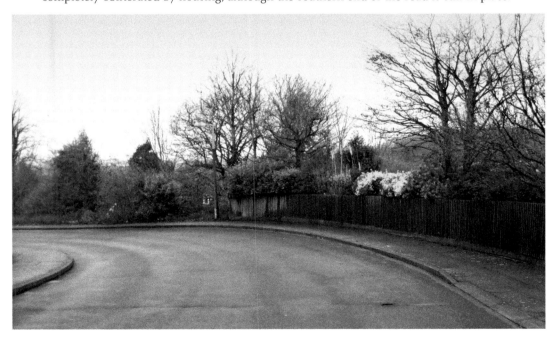

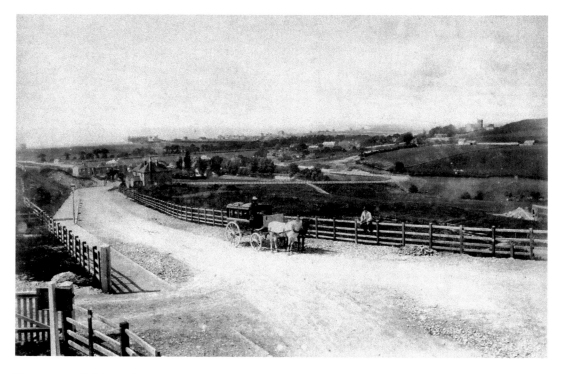

View towards Hythe from the Railway Station

The photograph, dating from *c.* 1878, was taken from the railway station, looking towards the town, and shows the isolation of the station in its early days. One of the entrances into the station can be seen on the left. The horse bus in the centre of the photograph ran between the Swan Hotel in the High Street and the station. The modern photograph shows that housing was developed along both sides of the road from the late-Victorian period.

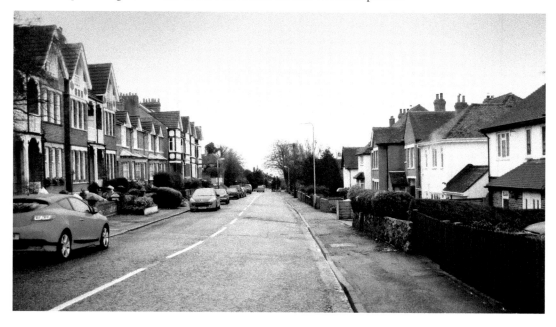

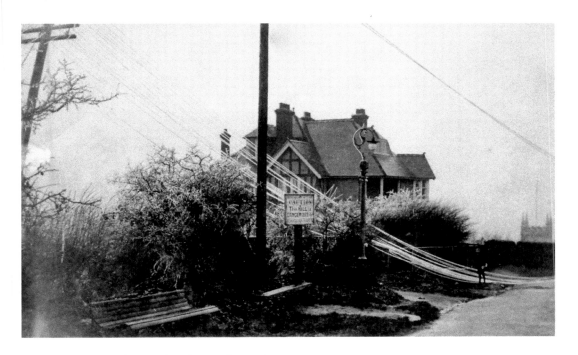

Broken Telephone Wires in Castle Road

A severe glazed frost brought down these telephone wires in Castle Road during the night of 17/18 January 1912. The house that can be seen is Highcliffe and the sign between the post and lamp-post reads: 'Caution. This hill is dangerous for vehicular traffic.' This refers to Church Hill, which commences where the top of St Leonard's church tower can be seen. The modern photograph shows Highcliffe undergoing roof repairs in 2010.

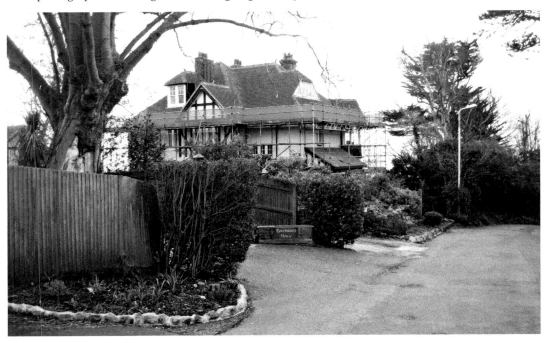

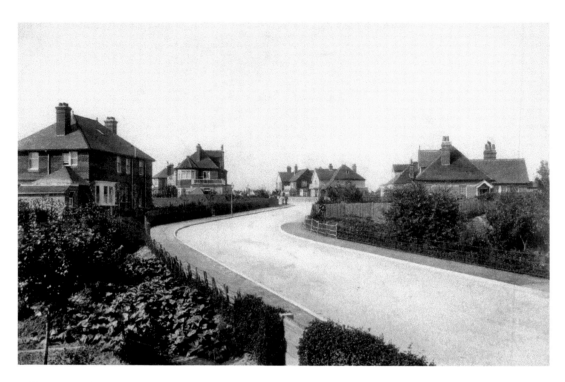

Hillcrest Road

Hillcrest Road runs between North Road and Castle Road and this photograph shows the view from Castle Road in 1902, when only sporadic development had taken place. The house on the left is Mayfield (now Hayfield), which has now been greatly altered, and the house on the right has also been extended. The gaps have subsequently been filled with housing in a pastiche Edwardian villa style.

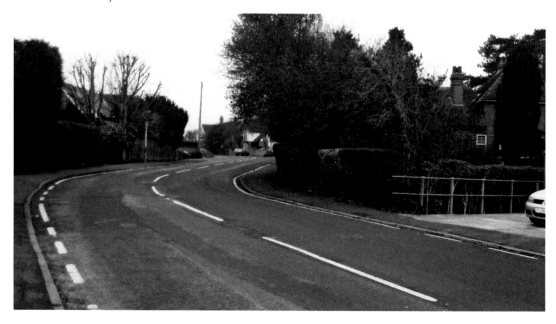

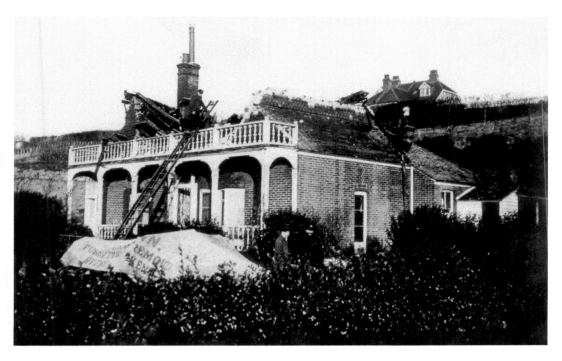

North Road Fire

The remains of Clyne House, North Road, photographed the day after it was destroyed by fire on 30 January 1911. The house was occupied at the time by F. W. Butler, Mayor of Hythe at this time. The premises were rebuilt, and Miss M. H. Fuller was the next occupant, but as can be seen in the modern photograph, the house is currently empty.

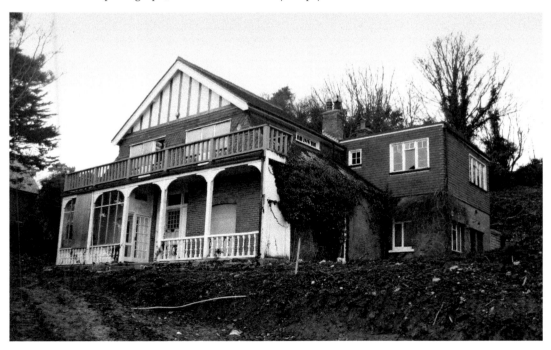

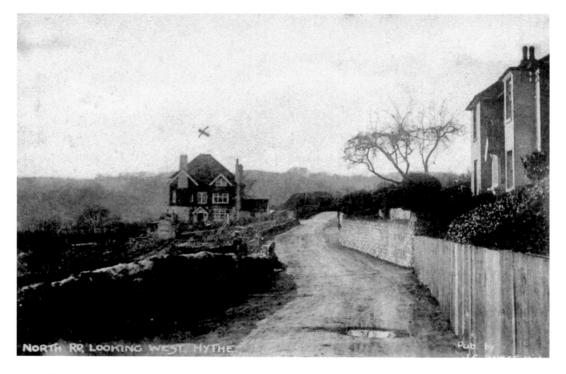

North Road (Looking West)

A postcard sent in 1914, showing the western end of North Road. The sender is staying in the house marked with a cross, which was called Mistedon and situated on the corner with Barrack Hill. The house still survives and can just be seen through the trees. The property on the right, called Quarry House, and its wall are also survivors from 1914.

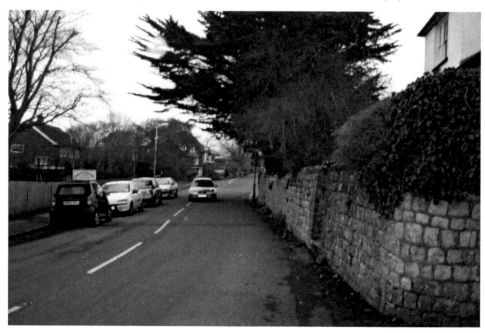

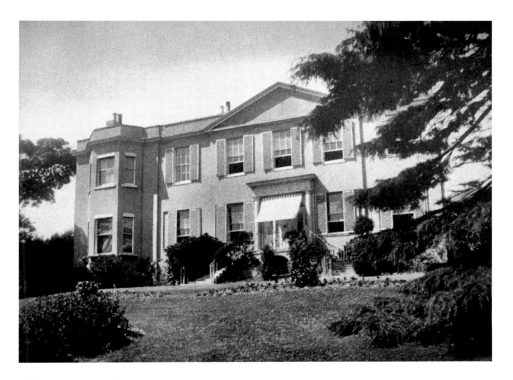

Hill House, Bartholomew Street

Hill House was a fine Georgian house of architectural interest, and this photograph was taken in 1928, when the property was up for sale. The sale catalogue states that it had ten bedrooms, a study, drawing and dining rooms, and domestic quarters. The house was converted into flats but became ramshackle under the ownership of Richard Redfern and had to be compulsorily purchased by Shepway District Council. Despite hopes that it could be saved, Hill House was demolished in 1986 and replaced by Homepeak House.

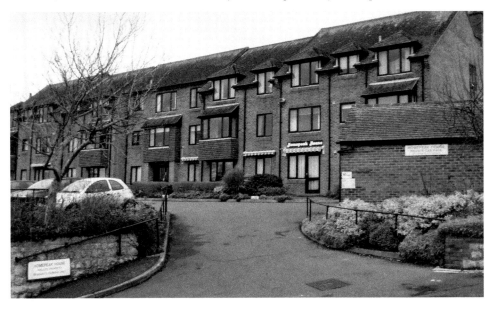

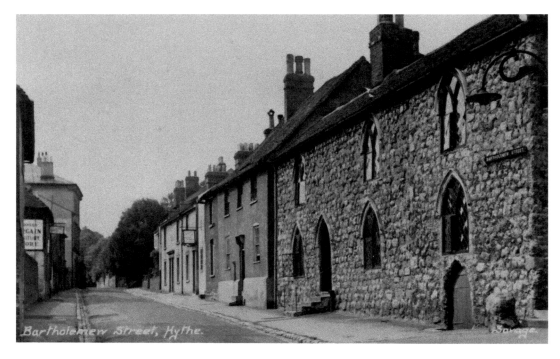

Bartholomew Street

A view looking west along Bartholomew Street in the 1920s. The medieval building on the right is St Bartholomew's Hospital, also known as Centuries, established in 1107 as a poor house and now almshouses. The property next door is the Yeoman's House and the tall building on the left is known as Brewery Buildings: this once housed a pub called the Prince of Prussia. The street is remarkably unchanged today.

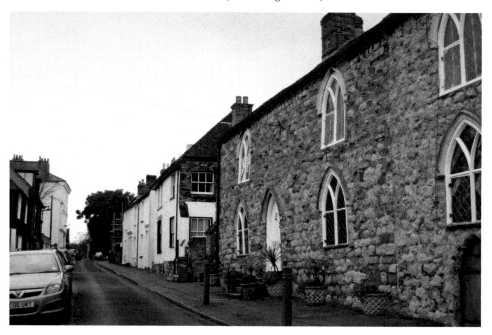

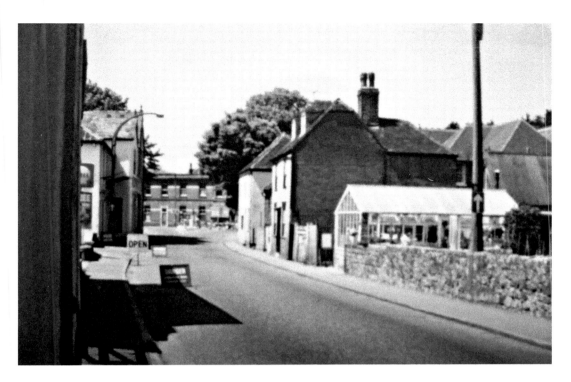

East Street (Looking West)

East Street looking towards Prospect Road and the High Street in the early 1970s. The Shell petrol sign of Caffyns Garage can just be seen on the left and on the right is W. S. Bloggs' nursery and Hogben's second-hand furniture premises. These were demolished in the 1980s to allow the road to be widened and were replaced by new housing and one shop.

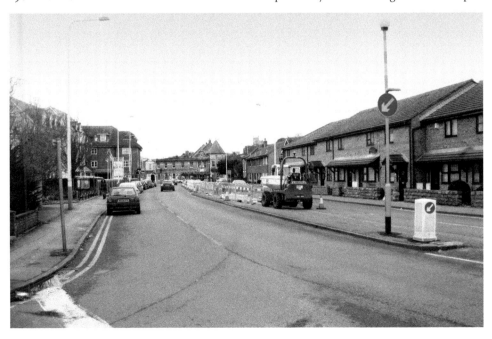

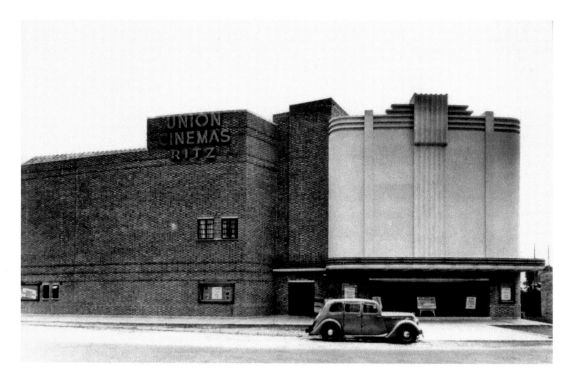

Ritz Cinema

The Ritz Cinema was opened on the corner of Prospect Road and East Street on 12 June 1937. The Art Deco-style building seated 858 people and boasted air conditioning, although a projected café never opened. In 1971, falling attendances led to the building being converted to a bingo hall, although a small cinema, seating 276, was retained in the circle. However, the Ritz was finally closed on 7 August 1984 and was demolished to make way for the Blythe Court complex of apartments.

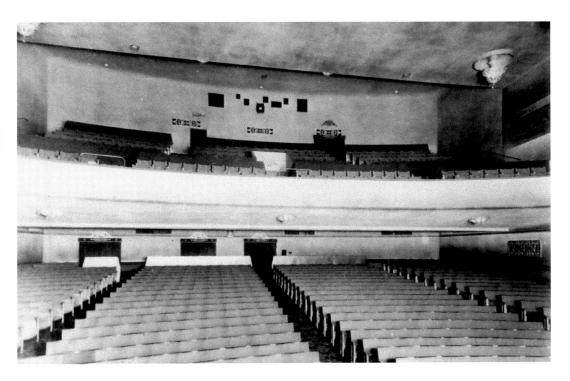

Interior of the Ritz Cinema

Two rare interior views of the Ritz Cinema, taken in the 1950s, showing the balcony from the stage (top) and the screen and stage from the balcony (bottom). The auditorium featured backlit ornamental insets draped with heavy satin. The first film shown at the Ritz was *Keep Your Seats, Please* starring George Formby.

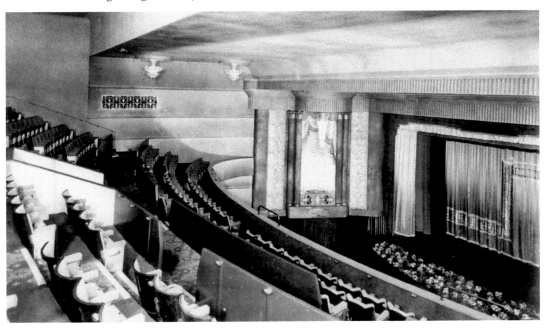

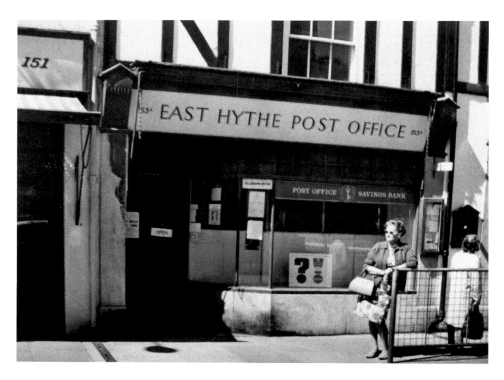

East Hythe Post Office

The East Hythe Post Office at 153A High Street pictured in the 1970s. From 1902 to 1923, it had been situated at No. 139 as part of a grocer's shop before moving back to this site. In 1972, the shop became Hythe (Kent) Models, which closed in 2007, and is now the Chocolate Deli shop.

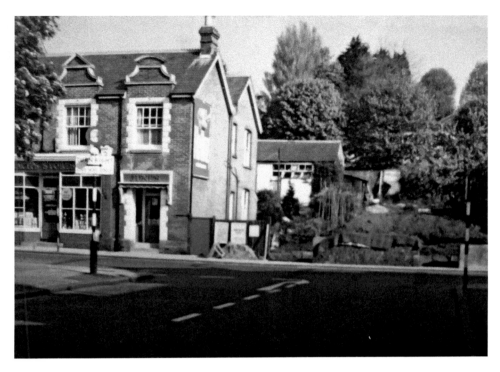

Leach's Stores, High Street

Leach's grocery store and June's hairdresser's at 139 High Street in the early 1970s: Leach had been established on the site since 1932. In 1973, Nos 135-139 High Street were demolished to make way for a new post office and job centre, which in 2010 are the Hythe Bath and Shower Centre.

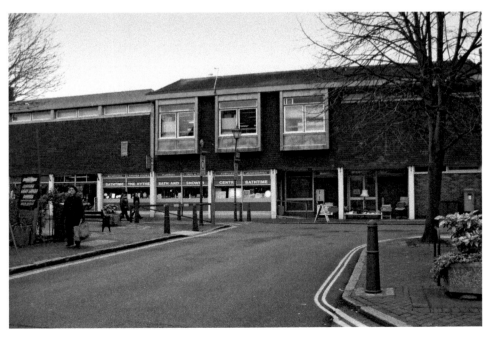

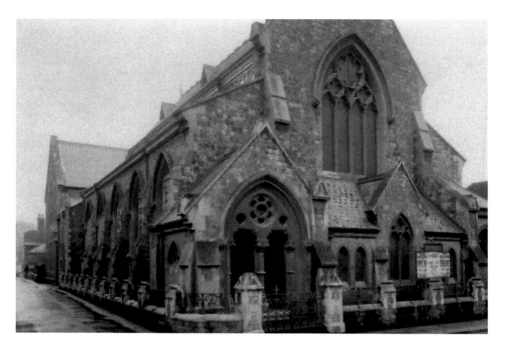

Congregational Church

The Congregational Church in the High Street, seen here around 1910, was built in 1868 at a cost of £2,500. In 1872, a small school was added, which was later used as the church hall. The church was demolished in 1987 upon the opening of the United Reformed Church in East Street and was replaced by housing.

The Picture Palace

Hythe's first permanent cinema was the Picture Palace, opened at 111 High Street (107 from 1915) on 12 April 1911 as the Hythe Electric Theatre: the name was altered in May 1912. The cinema was particularly popular with Canadian soldiers during the First World War, but was closed in May 1927 upon the opening of the Grove Cinema in Prospect Road. The building was demolished for a parade of shops, which were destroyed by a German bomb on 4 October 1940. Four new shops were built on the site of the Arcade in the early 1960s.

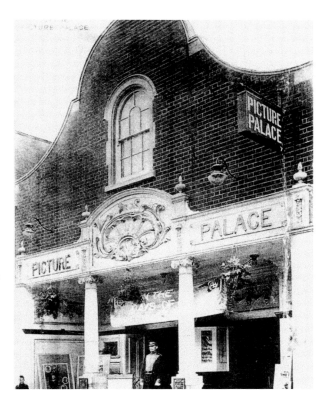

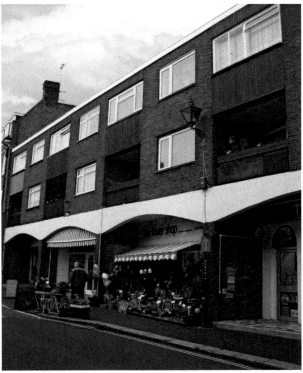

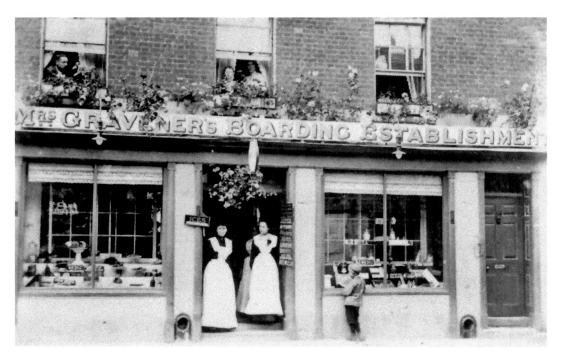

Mrs Gravener's Boarding Establishment

Mrs Ellen Gravener's Boarding Establishment and Tea Rooms, 112 High Street (renumbered No. 105 in 1915), photographed in 1906. In 1921, the premises passed to Mrs Marjorie Pain, but were pulled down in 1928 to make way for the Arcade, a group of ten small shops. However, the Arcade was destroyed by a bomb on 4 October 1940. Four new shops were erected in the early 1960s and No. 105 is currently occupied by the Shelter charity shop.

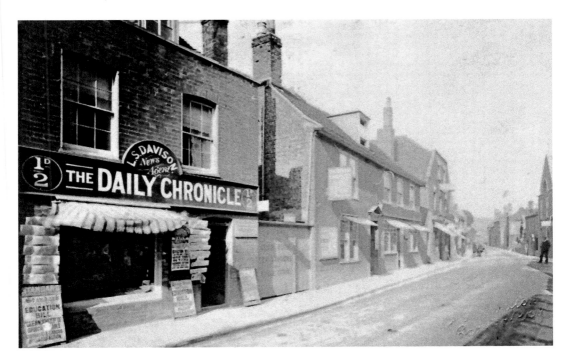

Davison's Newsagent's, High Street

Leonard Sidney Davison's confectionery, newsagent and tobacconist shop at 115 High Street (renumbered No. 99 in 1915), *c.* 1910. Mr Davison took over the premises around 1907 and remained there until 1923, when it passed to Reg Driver. The building next door housed a firm of rate collectors and the Wilberforce Temperance Hotel. No. 99 is currently Owlets jewellers shop, but the Wilberforce Hotel was rebuilt in 1933 as Woolworths (now a pound shop) and Sainsbury's (now J. C. Rook).

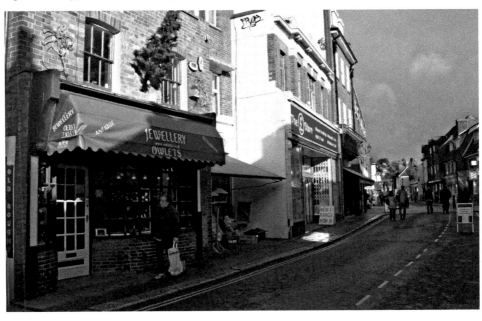

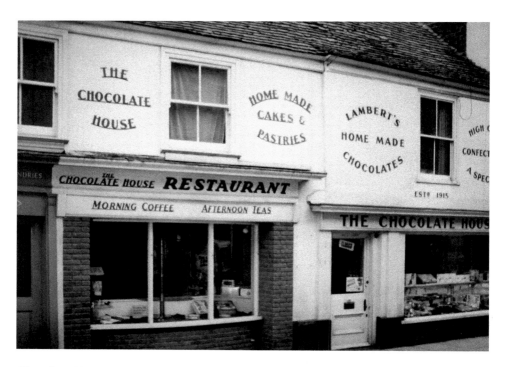

Chocolate House Restaurant

The Chocolate House Restaurant was a long-established business at 116-118 High Street. First opened in 1915 at No. 116, it was expanded by H. T. Lambert into next door in 1958. Between 1974 and 1988, the shop housed garden supplies and then a doctor's surgery until 2007 and is now La Patisserie.

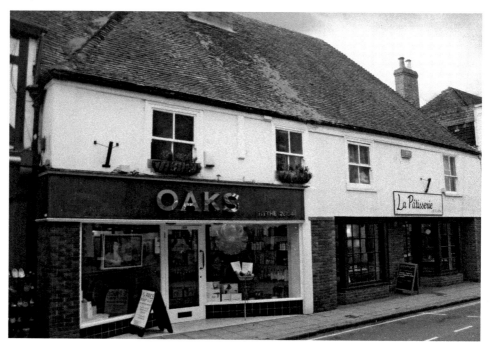

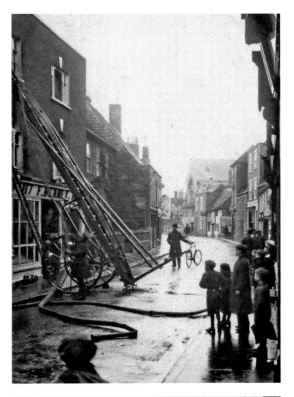

Beaney's Fire, High Street
The aftermath of a fire at F. Beaney's fishmonger's and fruiterer's shop at 93 High Street in October 1910. The fire had been caused when Mr Beaney's mother tripped over holding an oil lamp, which set light to the room. The upper floors of the building were gutted, although, fortunately, there were no injuries.
By 1913, the premises had become a hairdressers' establishment and is now Fell Reynolds estate agents.

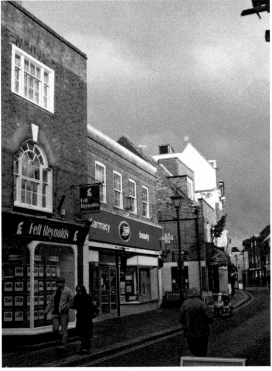

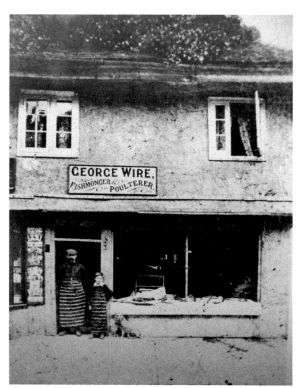

George Wire's Shop, Smugglers Retreat
George Wire's fishmonger's and poulterer's shop was opened in 1905 in the famous Smugglers Retreat in the High Street, which dated back to around 1500. However, Wire's stay was short-lived, as the building was demolished in 1907 and replaced by three shops in a mock-Tudor style. Ideas gift shop has been on the site since 1988.

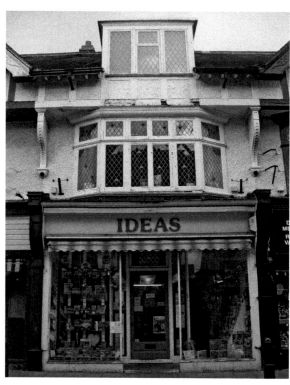

Marine Walk Street

Marine Walk Street acquired its name because it led to the Marine Walk (more popularly known as Ladies Walk), a tree-lined walk from the Royal Military Canal to the sea. At the time of this deserted scene from around 1900, the thoroughfare housed a plumber's workshop, coal merchant's, confectioner's shop, phonograph stores, and Cobay's workshops, in addition to some houses. A few business premises are still trading in the modern view.

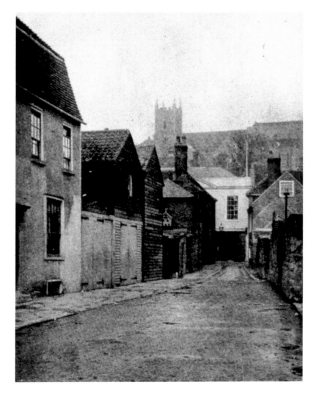

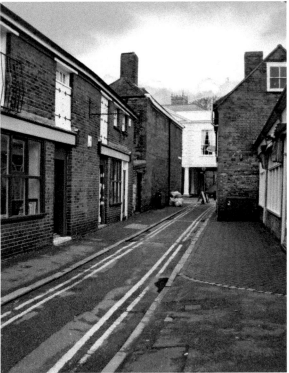

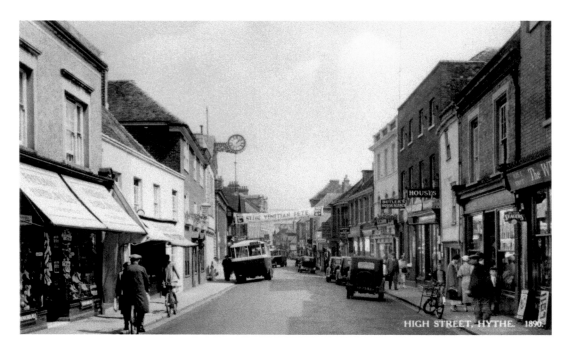

High Street (Looking East)

Looking east along the High Street in the mid-1930s with a bus parked outside the town hall and a Venetian Fête banner strung across the road. On the left is the Freeman, Hardy & Willis shoe shop, which had been there since 1909, whilst on the other side of the road is Dan West, wine, spirit and beer merchant; Fredrick Longley, fruiterer and florist; and F. W. Butler & Cobay, house agents. The 2010 photograph shows there is still a shoe shop and the buildings haven't changed much.

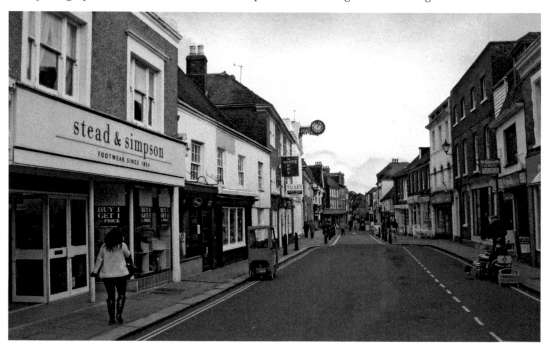

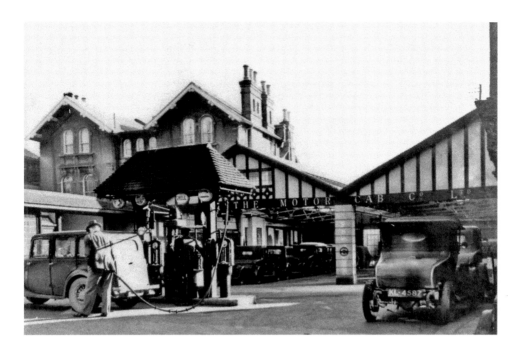

Hythe Motor Cab Company

A photograph of the Hythe Motor Cab Company's premises in the High Street in the 1930s. The business had been established in 1915 on the site of the Swan Livery Stables and offered petrol, servicing, repairs, taxis, and a driving school. In 1960, it was taken over by Southern Autos Ltd and four years later became part of the Caffyns group until closure in 1976. An International supermarket was built on the site, which is now Aldi. The Cinque Ports Club building (now a restaurant) in the background has been partially demolished.

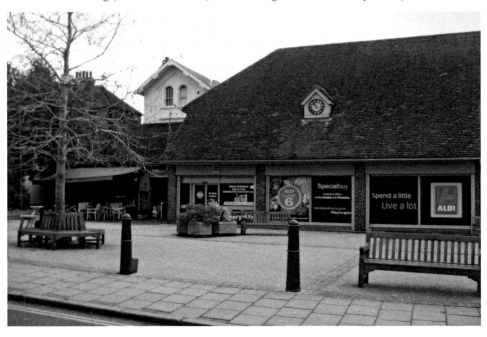

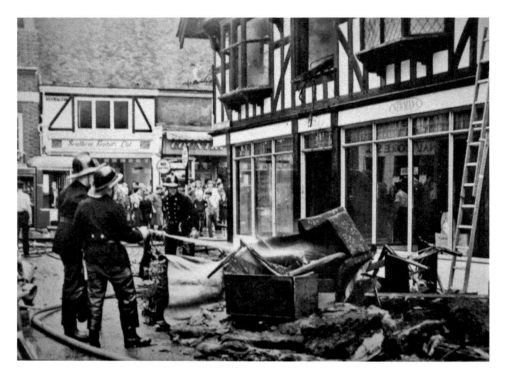

Newman's Fires, High Street

Newman's house furnishing shop has been established at Nos 64-68 High Street since 1952 but has suffered two major fires during its time there. The photo above shows the aftermath of a fire in 1965, the lower photo a night-time blaze on 28 April 1984. The shop was rebuilt to the same design on both occasions and now trades as Furniture World.

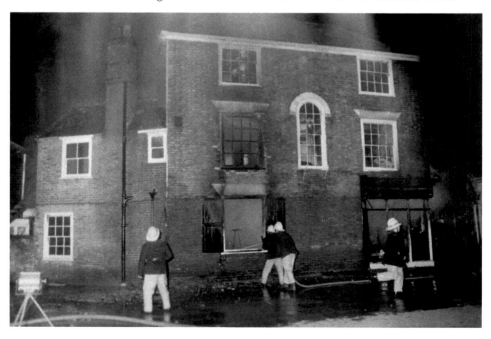

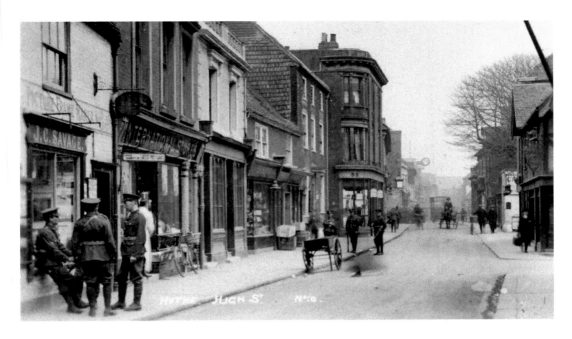

High Street (Western End Looking East)

The western end of the High Street looking towards the town hall around the time of the
First World War, with a number of military personnel on view. The soldiers are standing
outside the shop of photographer John Charles Savage, who was there from 1907 to 1945.
Next door is another long-time occupant, the International Stores, in situ from 1898 to 1973.
Adjoining it is the Midland Bank, which would be rebuilt in 1923. Savage's is now Sarah
Jane's Catering Company, International Stores is Your Move estate agents and the Midland
is now the HSBC Bank.

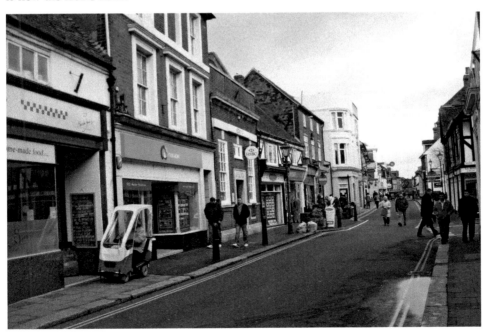

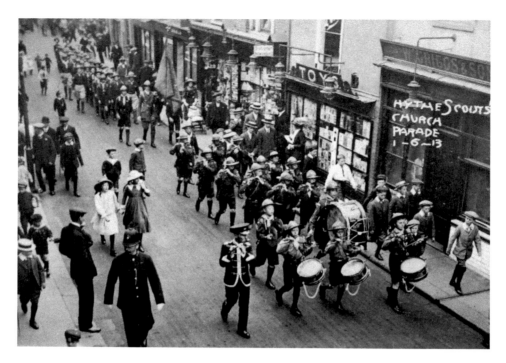

Scouts Church Parade

The Hythe Scouts Church Parade marches along the High Street on 1 June 1913. W. Griggs fishmonger's shop can be seen at No. 87 (No. 46 from 1915) and next door is Henry Lee's newsagent's, tobacconist's and toy shop. Griggs moved along the road to No. 58 in 1921. The buildings remain, housing card and charity shops.

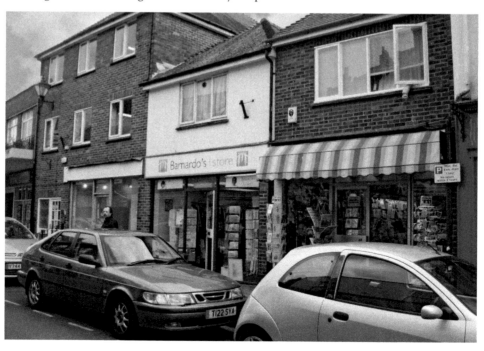

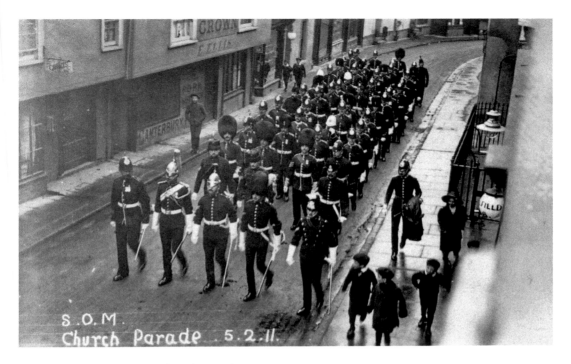

School of Musketry Church Parade

The School of Musketry look resplendent as they march along the High Street during Church Parade on 5 February 1911. Note the three small boys walking with them! Behind the soldiers is the Rose & Crown Inn, which closed in 1971. The landlord at the time of the parade was Edward Ellis; who was at the inn from 1909 to 1923. The former pub is now Thailand Tom's restaurant.

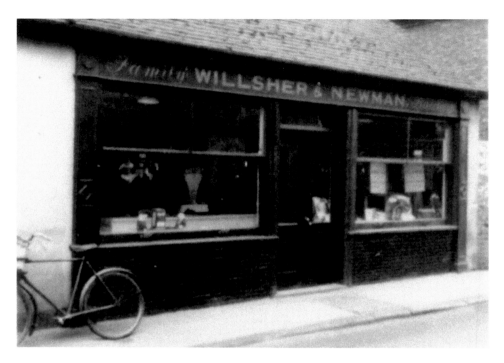

Willsher & Newman, Chapel Street

A photograph of Willsher & Newman's butchers' shop in Chapel Street, which traded from 1923 until 1967. Next to the shop was the back entrance to the garage in Rampart Road and a saddling business that catered for the horses of the Mackeson's Brewery. A house now stands on the site of the shop.

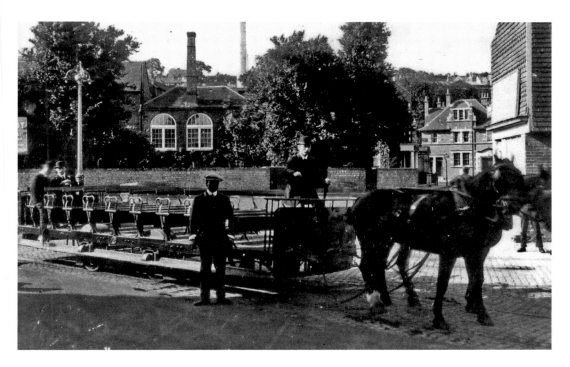

The 'Toast Rack' Tram and Mackeson's Brewery

The 'Toast Rack' tram of the Hythe and Sandgate horse tramway stands in Red Lion Square, *c.* 1910. The tramway opened in 1891-92 and closed on 30 September 1921. In the background is the famous Mackeson Brewery, producers of the renowned milk stout. Brewing ceased at the site in 1968, and it was closed completely five years later. In 1983, sheltered housing was built on the site and it also houses a car park.

Properties set for demolition in Rampart Road

Looking from Red Lion Square to Rampart Road in the late 1960s, we see the house and café of Wilfred 'Dickie' Trice, which would soon be demolished for road widening. On the left, the restaurant and the building behind housed the stables of the horse tramway and still bear the fascia 'Folkestone, Hythe and Sandgate Tramways 1894'. At the present time, the restaurant is empty.

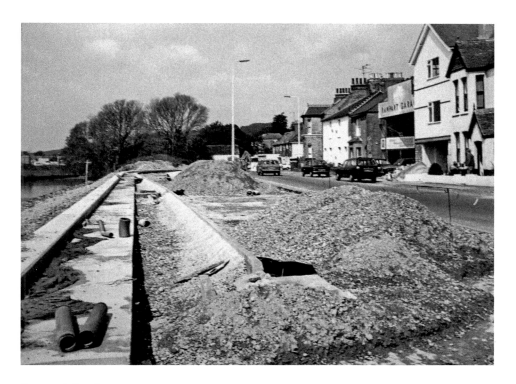

Rampart Road

Rampart Road in the process of being widened during the early 1970s following the demolition of Trice's Café as seen on the previous page. On the right can be seen the Rampart Garage, which was established in 1910 by Messrs Dray and then went through various ownerships before it was acquired by Messrs Baut and Hawes in 1933. In 1974, the garage was taken over by Peacocks but was demolished a few years ago to make way for the four rather striking houses seen in the 2010 photograph.

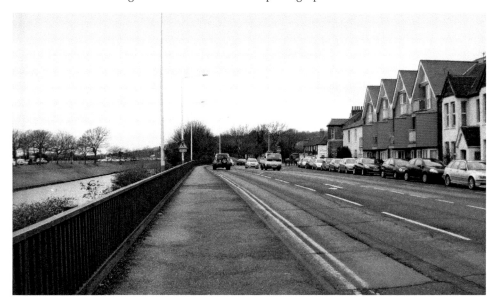

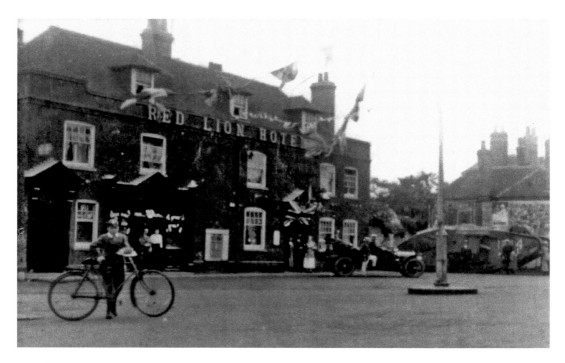

Red Lion Hotel

The Red Lion Hotel in Red Lion Square is decorated for the presentation of a First World War tank to Hythe on 11 July 1919. The tank, which can be seen on the right, was officially presented outside the town hall before being placed in the Grove along with a field gun. The Red Lion dates back to the seventeenth century, when it was known as the Three Mariners, and still trades in an era where many pubs are closing.

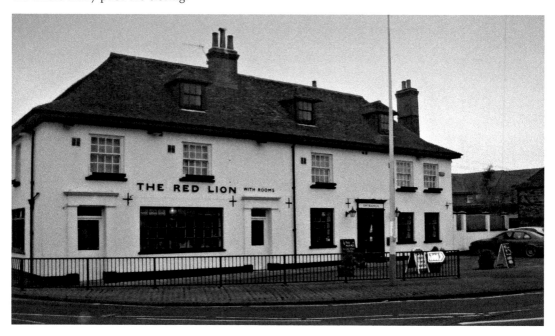

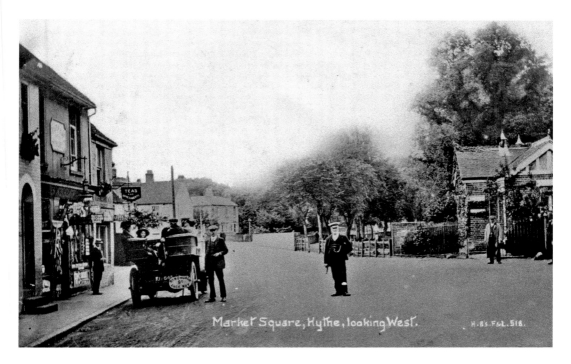

Market Square

Market Square was an alternative name for Red Lion Square and it is seen here, *c.* 1911, looking towards Market Street (now Dymchurch Road). The two premises on the left are Stephen Keeler, tobacconist's and confectioner, and Cowell's restaurant, which until 1905 was the Portland Arms. The private hire car is offering a ride to Dymchurch, 9*d* each way. The modern photograph shows that shops are now private houses.

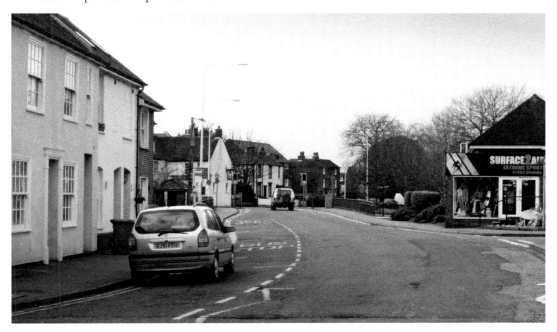

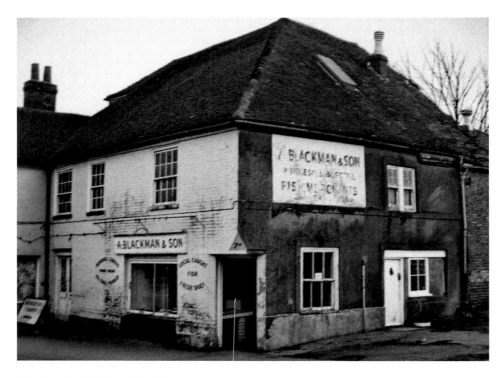

Blackman's Fish Merchant's

The Blackman family were one of the well-known fishing families of Hythe (the other was the Messrs Griggs) and their locally caught produce was sold in this shop at 7A Dymchurch Road from the early 1920s. In 1988, Blackman's moved to 41 High Street and this building was demolished to make way for the Red Lion Court block of apartments.

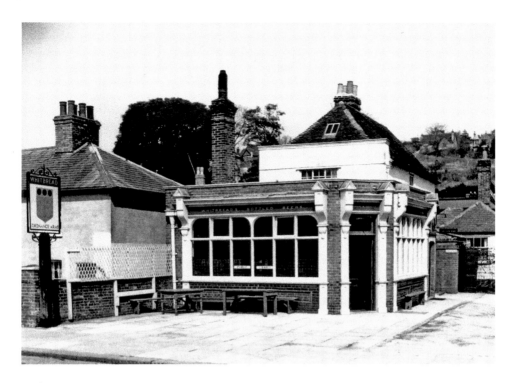

Ordnance Arms

The Ordnance Arms was situated close to the Small Arms School (School of Musketry) in Military Road and dates from at least 1843. This photograph was taken in 1941, when it was held by Whitbread, having previously been owned by the Mackeson Brewery. The Ordnance Arms was demolished in 1973 and was replaced by a petrol station. The adjoining Military Terrace can be seen in both photographs.

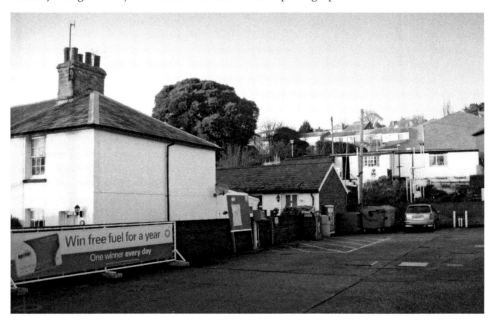

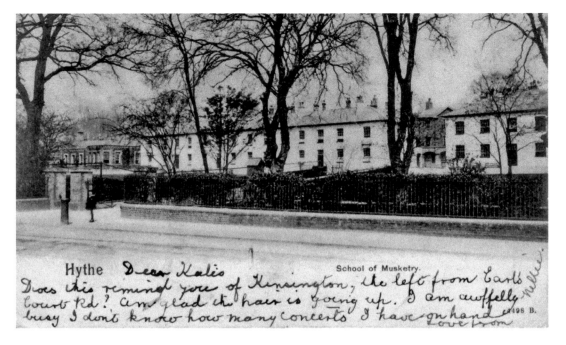

Hythe *Dear Katie* School of Musketry.

Does this remind you of Kensington; the left from Earls Court Rd? Am glad the hair is going up. I am awfully busy I don't know how many concerts I have on hand. Love from Nellie.

School of Musketry

The School of Musketry in Military Road featured on a postcard in 1903. The barracks were built in 1805-10 during the threatened Napoleonic invasion and were occupied by the Royal Staff Corps until 1838. The School of Musketry was transferred to Hythe in 1853 to give training on the recently introduced Enfield rifle. In 1919, the name was altered to the Small Arms Wing, but in 1968, the school was closed and was largely demolished to make way for residential and industrial development.

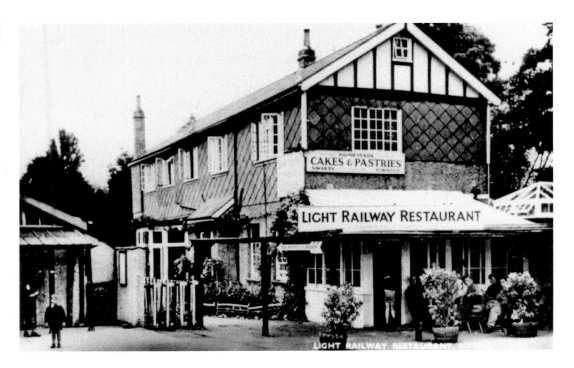

Light Railway Restaurant

The Light Railway Restaurant was opened in 1927, the same year as the adjoining Romney, Hythe & Dymchurch Railway station. Indeed, the café was originally to have been operated by the railway, but instead was sold into private hands. This postcard shows the café in the 1930s, when homemade cakes and pastries were a speciality. The café still trades and it can be seen in the recent picture that it has been extended.

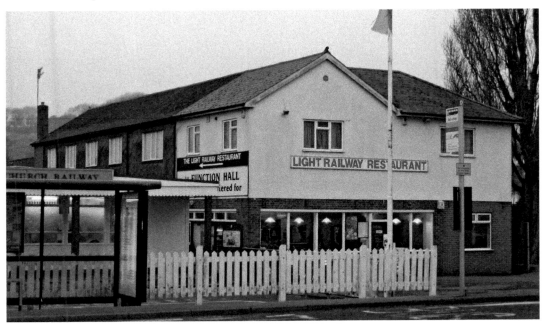

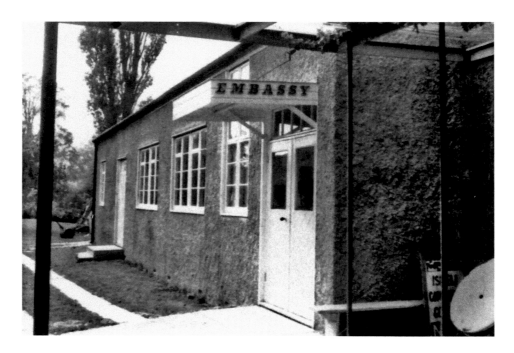

Embassy Cinema

The short-lived Embassy Cinema was situated behind the Light Railway Restaurant adjoining the Romney, Hythe & Dymchurch Railway station. The cinema could seat 100 people, but was only opened between 1970 and 1972. The hall is now used for farmers' markets, boot fairs, and as a function hall.

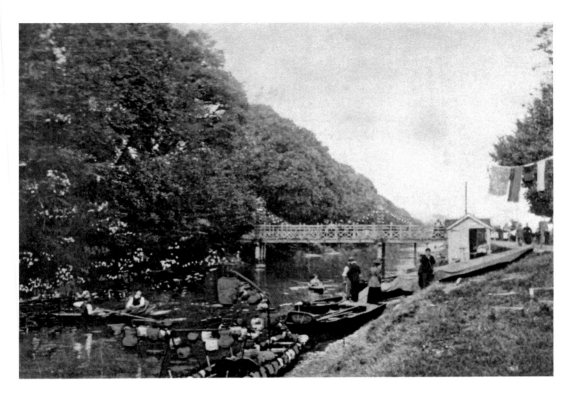

Venetian Fête

Venetian Fête day on the Royal Military Canal, *c.* 1880. The fête was established in 1860 as part of Hythe Cricket Week and grew to be a feature of Hythe's summer season with its procession of decorated craft along the canal. Since 1955, the event has been biennial. The bridge collapsed during the 1895 Venetian Fête after too many people had gathered on it. The modern photograph was taken during the 2009 event and shows the Wizard of Oz float.

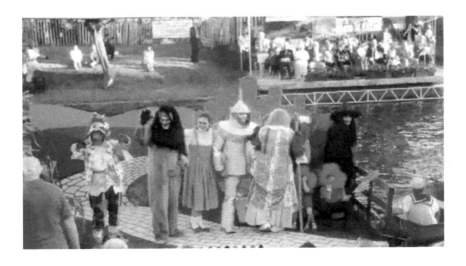

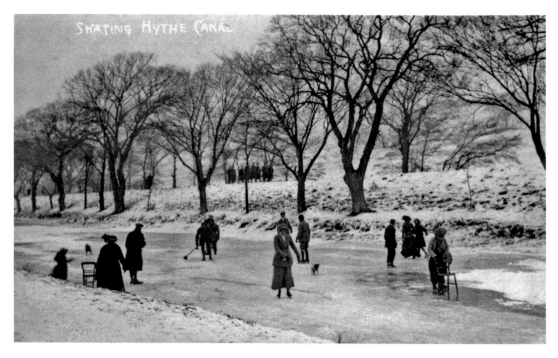

Skating on the Royal Military Canal

The Edwardian period was renowned for some very cold winters, particularly in 1908, 1909 and 1912. This postcard shows the Royal Military Canal frozen over and the ice thick enough for people to skate on. Note the ladies with chairs and the little dog! The canal has not frozen over for many years now, but the recent photograph was on a suitably cold winter's day!

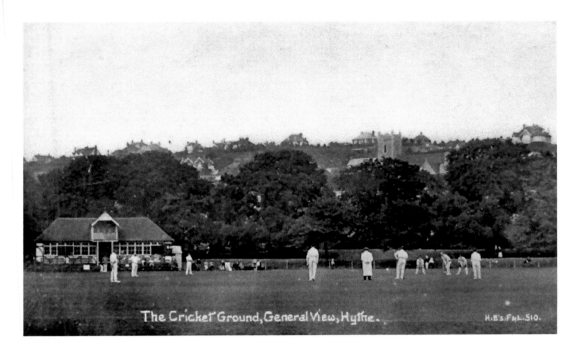

The Cricket Ground, General View, Hythe. H.B's.FaL.510.

Cricket Ground

The Hythe Cricket Club was founded in 1856, and its members have played at this ground adjoining the canal ever since. The Hythe Cricket Week was one of the social highlights of the year and many well-known cricketers have featured in the matches. The club's most famous cricketer was Percy Chapman, captain of Kent and England. The pavilion seen in the *c.* 1910 photograph above was sadly burnt down in 2004, but the new pavilion seen below was opened by ex-Kent and England cricketer Derek Underwood in 2006.

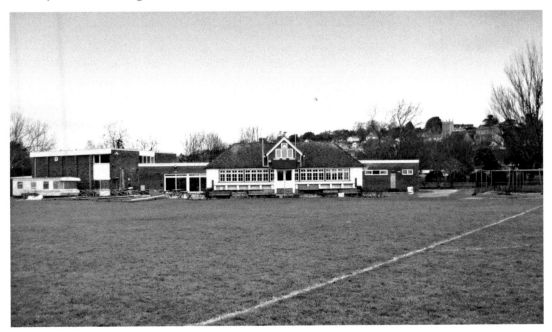

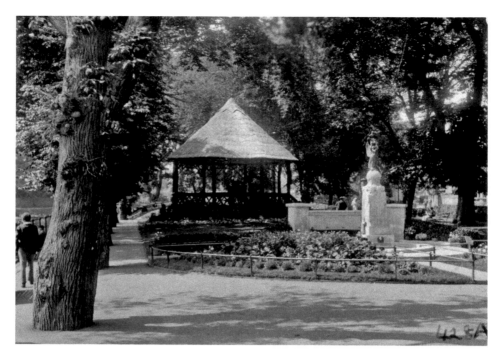

Grove Bandstand and War Memorial

The Grove Bandstand and War Memorial, photographed on a sunny day during the 1930s. The Grove was an attractive area of flowerbeds and trees bordering the Royal Military Canal. Sadly, the trees largely succumbed to Dutch elm disease in the 1970s, and the bandstand was burnt down. The War Memorial, designed by Gilbert Bays and unveiled by Earl Beauchamp on 16 July 1921, thankfully remains and records Hythe's 154 casualties of the First World War and the sixty-three from the Second World War.

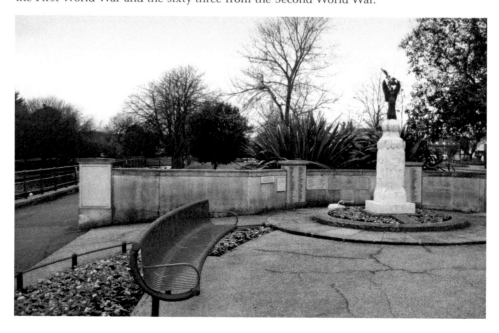

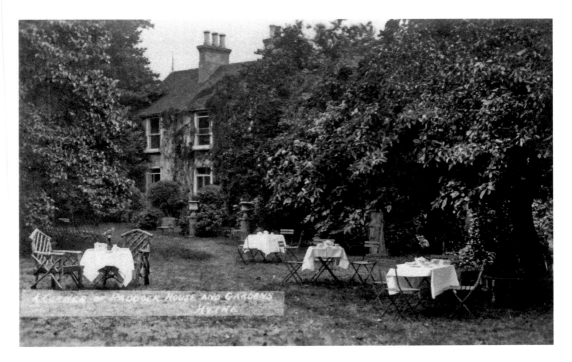

Paddocks House and Tea Garden

After being used as an army hospital in the First World War, Harry Cobb opened a tea garden in Paddocks House, Prospect Road, in 1920, the year that this postcard was issued. However, by 1927, the house was being used as a boarding house and currently is a home for those with learning disabilities. The modern photograph shows that road widening has accounted for part of the former tea garden.

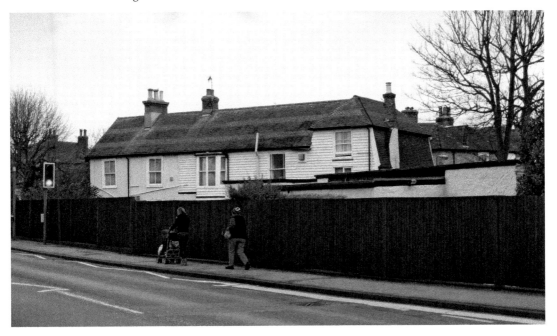

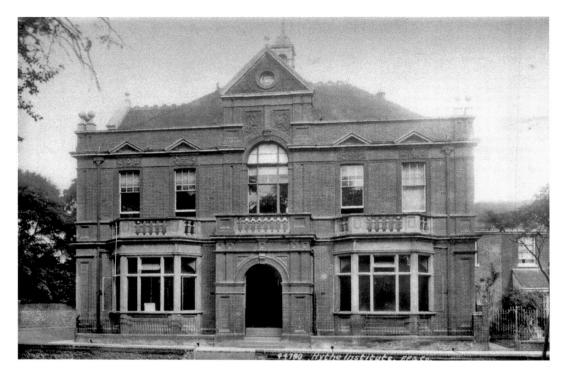

Hythe Institute

The Hythe Institute was situated on the corner of Mount Street and Prospect Road and was erected by local builder and benefactor Alfred Bull in 1891-92 for use as a concert hall, reading and meeting room and subscription library. The subscriptions, along with rents from Bull's cottages helped maintain the building. During the Hythe Cricket Week, the Institute would hold a variety of functions. Sadly, the building was demolished for road widening in 1968.

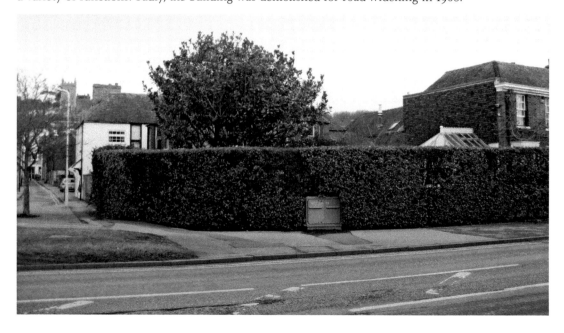

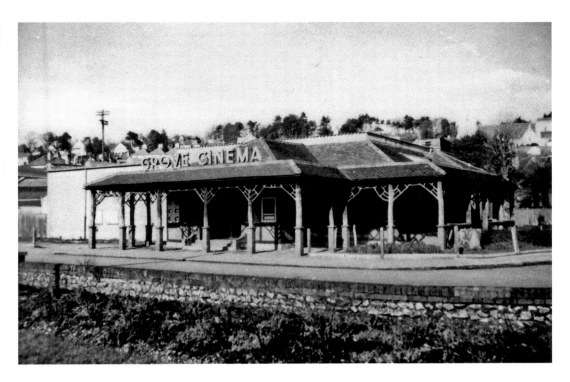

Grove Cinema

The Grove Cinema was situated on the opposite corner of Mount Street and Prospect Road to the Institute and is pictured here about the time it was closed on 1 March 1958. Affectionately known as the 'Shack', the Grove was opened on 16 May 1927 to a design by A. E. Palmer and could seat 650. Following closure, the cinema was used as a car showroom (as seen below) before it was demolished in 1968 for road widening.

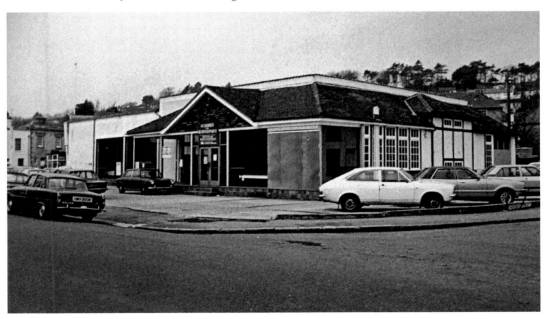

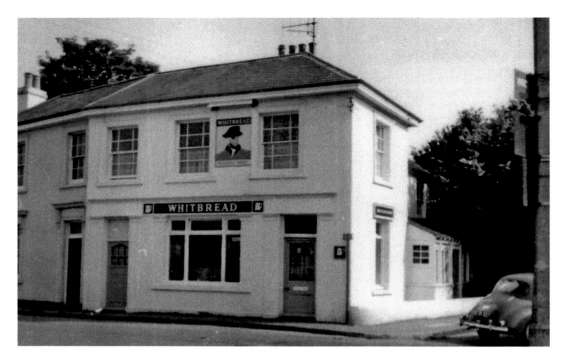

Nelson's Head Inn

Possibly originally known as the Shoemaker's Arms, the Nelson's Head was so named by James Nelson in the 1840s. In 1880, the pub passed into the hands of the local Mackeson Brewery. The pub sign showed Lord Nelson, but in 1966, around the time this photograph was taken, it had to be redesigned when it was found that the patch covered the wrong eye! The Nelson's Head was closed on 10 October 1974 and became the Nelson Griddle: it is now Sotirio's restaurant.

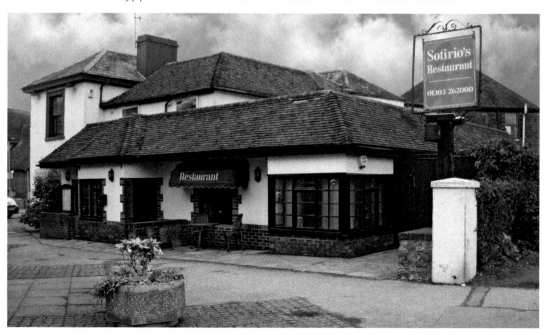

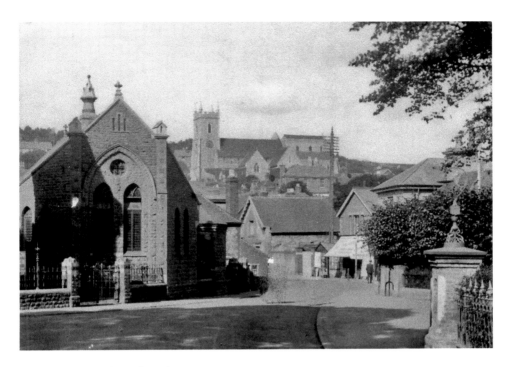

Methodist Church and Bank Street

The top photograph was taken from Nelson's (Stade Street) Bridge looking over Rampart Road into Bank Street, *c.* 1920. The Methodist Church on the left was built in 1897 to replace an earlier building and behind the trees on the right is the Nelson's Head Inn. The lower photograph was taken ten years later and shows the white extension building of the Hythe Motor Cab Company erected in 1927.

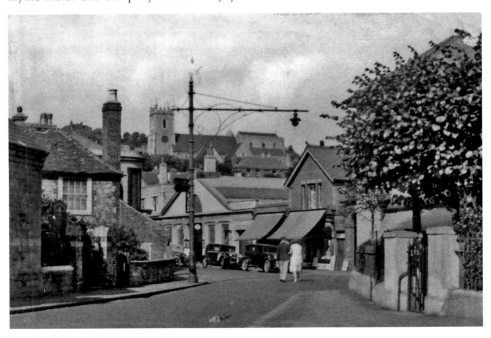

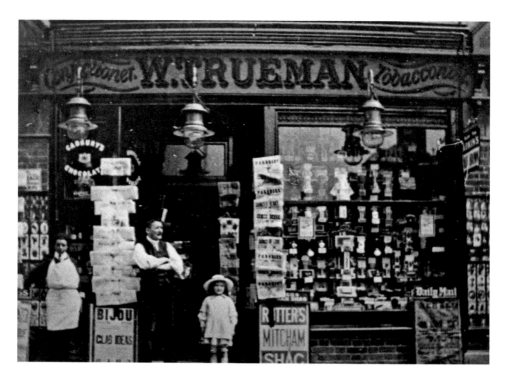

Trueman's Shop, Bank Street (1)

W. Trueman's newsagent's, confectioner's and tobacconist's shop in Bank Street, photographed in 1935. The business was established in 1906, but ceased trading during the Second World War. The lower photograph was taken following the demolition of the shop and the Hythe Motor Cab Company's premises (seen on the previous page) in the late 1970s.

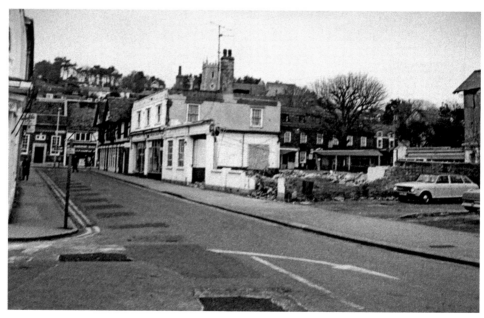

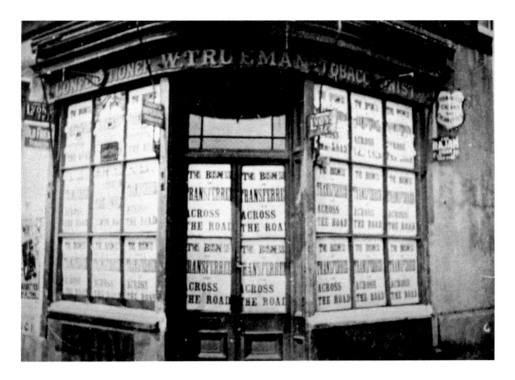

Trueman's Shop, Bank Street (2)

For a couple of years in 1930-31, Trueman's had an additional shop on the corner of Bank Street and Chapel Street opposite their main shop (as seen on page 56). This photograph was taken in 1931, when the shop had closed and was plastered with posters stating that the business had been transferred across the road. The building still survives and was in use as Café Costa in 2010.

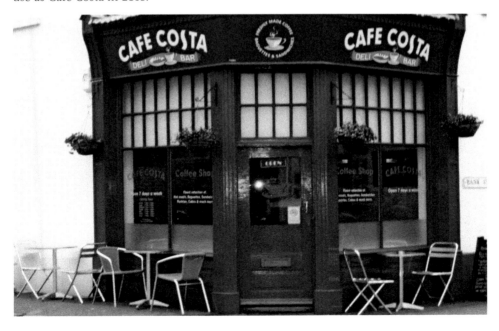

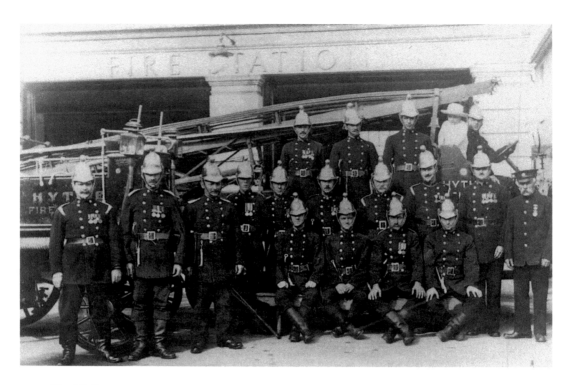

Fire Station

The Hythe Fire Brigade is the oldest in Kent, having been formed in 1802. They are seen here with one of their engines outside the fire station in Portland Road, which had been newly reconstructed in 1925. The brigade was originally volunteer-led and remained independent until absorbed into the Kent Fire Brigade in 1948. With a new station having been built in Wakefield Way, the old building is now Hythe Garage.

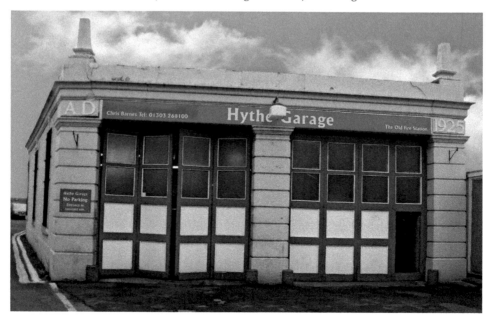

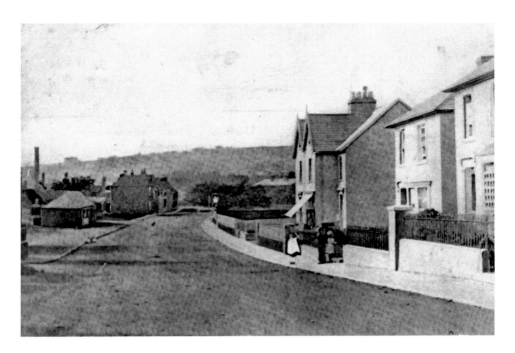

Stade Street

A photograph of Stade Street in 1875, which was reproduced on a postcard by the *Hythe Reporter* in 1903. In 1875, Stade Street was home to a number of lodging houses, the Star and Hope inns, two grocer's shops, a boot and shoe manufacturer, and a fish merchant. As can be seen in the modern photograph, the gabled building still survives, but the two on the right have made way for a block of flats.

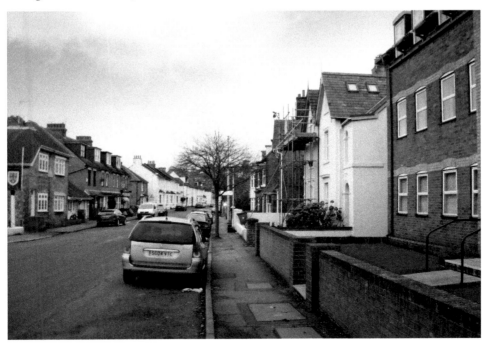

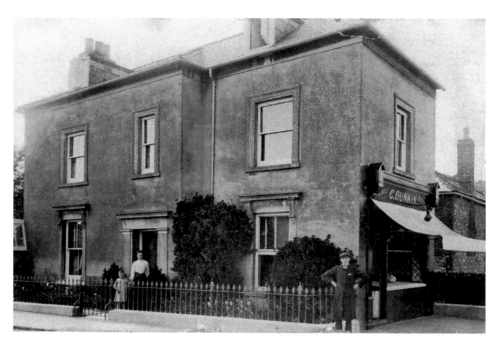

Dunkin's Butcher's on the Corner of Stade Street and Park Road
A photograph of Dunkin's butcher's shop on the corner of Stade Street and Park Road, c. 1910. In 1945, the shop was acquired by A. H. J. Matthews, who held it until the 1970s. The building was then home to a solicitor's office but is now a private house.

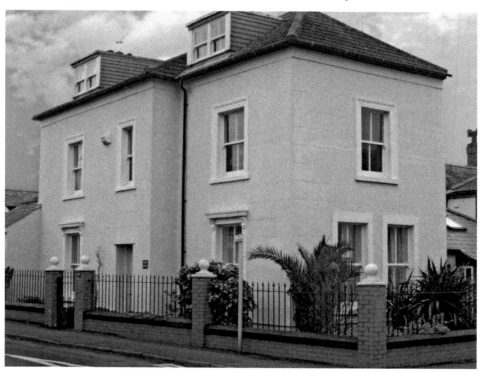

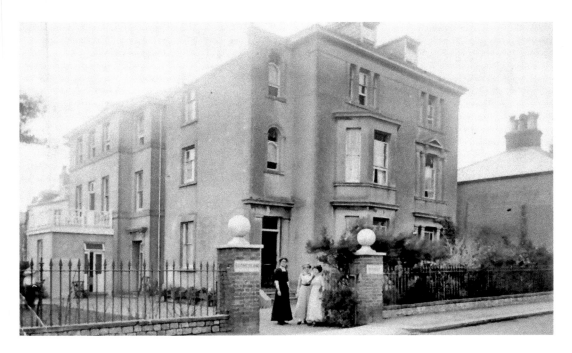

Sutherland House Hotel

The Sutherland Boarding House, Stade Street, photographed in 1912. The property was extended to become the Sutherland Hotel, which boasted forty bedrooms, central heating and lock-up garages. For the last thirty years of its life, the hotel was run by Mrs Elizabeth Stevenson and her two daughters, before work commenced in 1981 to convert the building into flats.

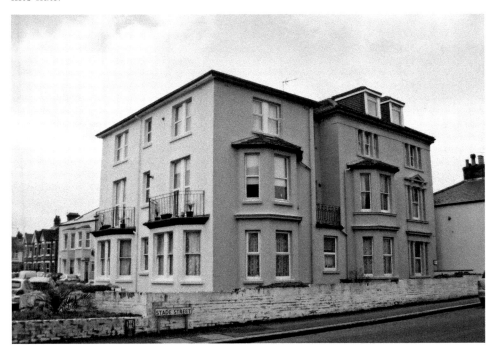

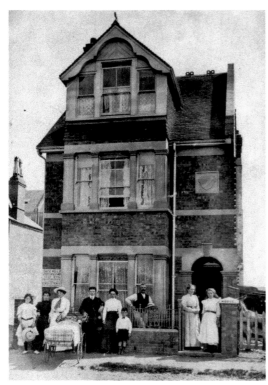

Galmpton House, South Road
An interesting postcard of Galmpton House, 18 South Road, taken in 1908. The house was built by Cornelius Wootten, who was living there but was offering it as a freehold sale (see the sign on the left of the house). On the right, a donkey can just be seen. The modern photograph shows that Galmpton House has not changed much and was one of a pair of houses, the other being named Salcombe, which cannot be seen on the 1908 photograph.

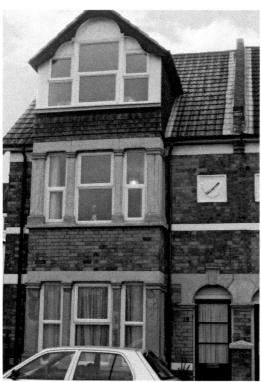

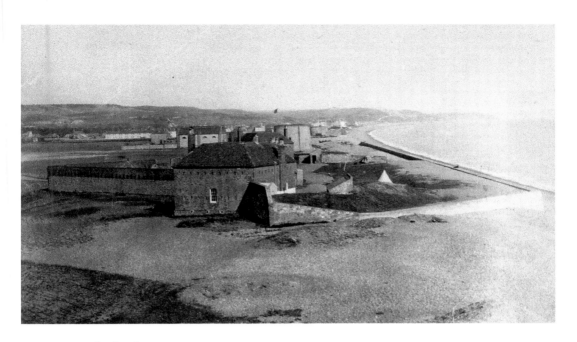

Fort Sutherland

Fort Sutherland was one of three forts erected in Hythe to combat the Napoleonic invasion threat of the late seventeenth/early eighteenth century. Built in 1798, the fort had a battery of eight 24-pound guns and could accommodate one hundred soldiers. By the time this photograph was taken in around 1890 from Martello Tower No. 15, the fort was being used as quarters for student officers; however, by 1906, it was ruinous and the remains were subsequently removed. Martello Towers 14 and 15 and the site of the fort between them are now on private MOD land and so this photograph was taken from the far end of the Fishermen's Beach.

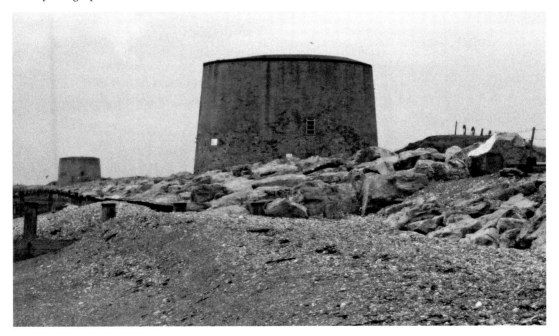

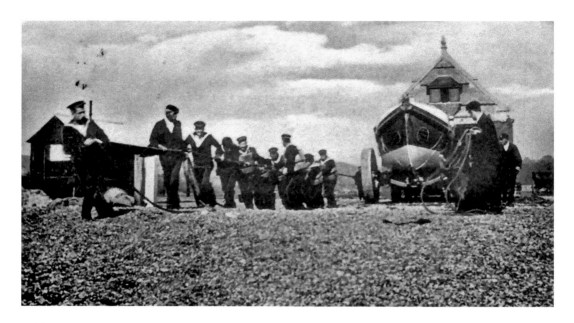

Lifeboat Station

The launch of the Hythe Lifeboat, *c.* 1904, captured by local photographer W. S. Paine. The lifeboat was transferred to the Fishermen's Beach from Seabrook in 1893 and a lifeboat house was erected at a cost of £570. The vessel being launched in this postcard is the *Meyer de Rothschild (II)*, on station between 1884 and 1910 with a record of twenty-seven lives rescued from twenty launches. A new lifeboat station was built in front of the old one during the 1930s and this can be seen in the modern photograph: the old house lies hidden behind it.

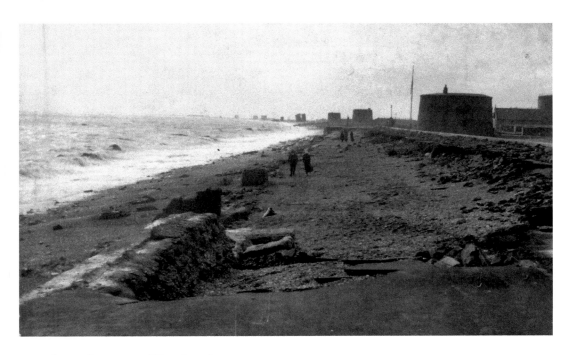

Storm Damage to West Parade

During the 'Easter Storm' of 22-23 March 1913, heavy seas scoured away the sea wall and promenade on West Parade, causing £10,000 worth of damage. The Martello Tower nearest the camera was later converted into a house in 1928, and behind the tower can be seen the now-demolished gasworks. The modern photograph shows the tower as a house and also the buildings that have been added beyond it.

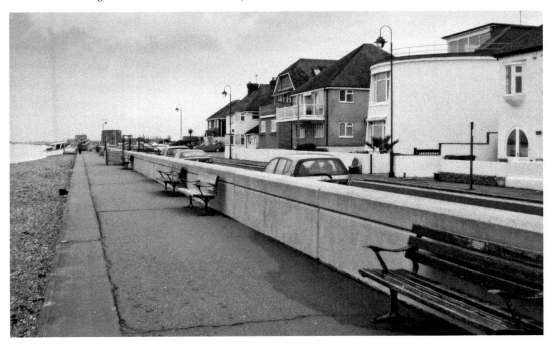

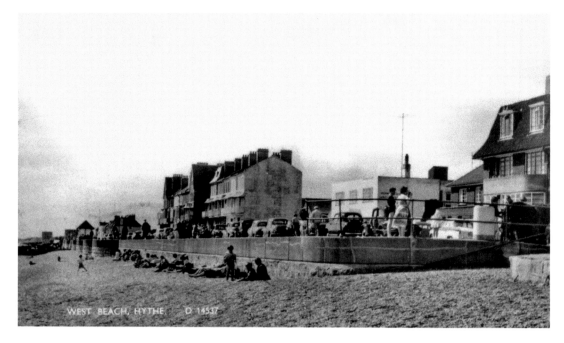

West Parade

A postcard of West Parade published in the late 1950s. West Parade was laid out in 1889-90 and Ormonde and Rostrevor terraces were erected (seen centre left). The concrete square building is the Four Winds café, built in 1938 on foundations laid by Mackeson's for a pub that was never built. Sadly, however, the Four Winds was closed in July 2005 and demolished the following year for Four Winds Court. On the right is the Stade Court Hotel, erected in the late 1930s on the site of old cottages.

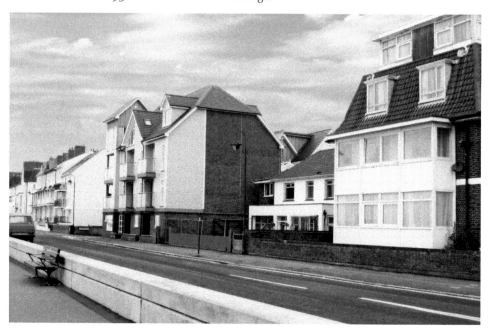

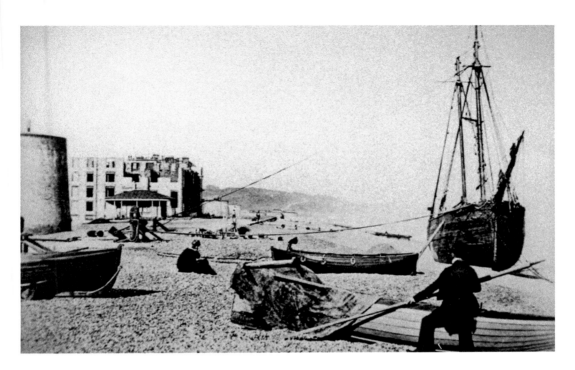

Marine Parade under Construction

This is a most fascinating photograph. Taken in around 1875, it shows Moyle Tower under construction but the remainder of Marine Parade as yet undeveloped. Of further interest are the rare views of Martello Tower No. 12 (nearest the camera) and No. 11 (just beyond Moyle Tower), which were demolished within a few years of the photograph being taken. The boats on the Stade were moved to the Fishermen's Beach once the beach was developed for tourism. The bottom photograph was taken around 1900 and shows the completed promenade and Moyle Tower. Note the bathing machines and cabins advertising Pears Soap.

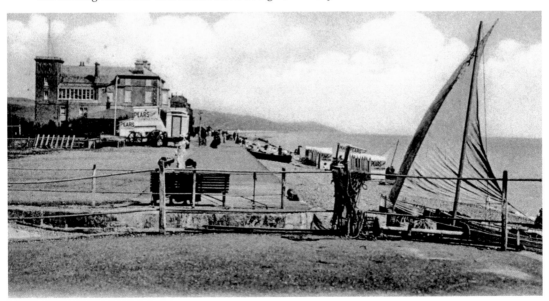

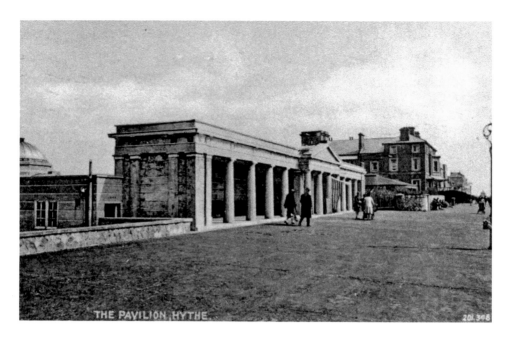

The Pavilion

Continuing on from the previous page, we see the same scene in the 1920s, showing the shelter on Marine Parade erected in 1924 in a classical style to complement the domed building behind known as the Pavilion. This was erected as a bath house and reading room by Hythe Corporation in 1854, but by the 1920s, it was in use as a tea room and restaurant. The Pavilion was closed in the early 1950s and Admiralty Court now stands on the site.

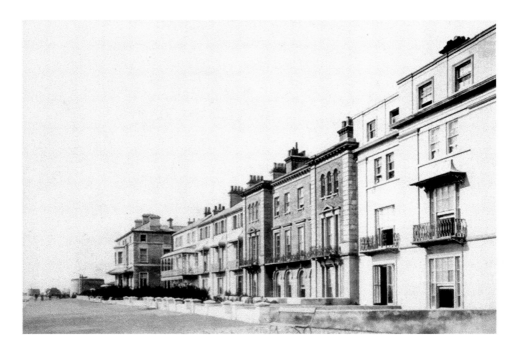

Marine Parade

Marine Parade in the late 1870s, just a few years after it was laid out by Hythe Corporation and the Hythe Land & Building Investment Company. The larger building centre left is Moyle Tower, which after lying empty when first built, became a private residence and then a Christian holiday centre. The Martello Tower was No. 12, which was demolished soon after this photograph was taken. The terrace of houses, originally known as the Marina, remains, but Moyle Tower was replaced by the Moyle Court block of flats in the 1980s.

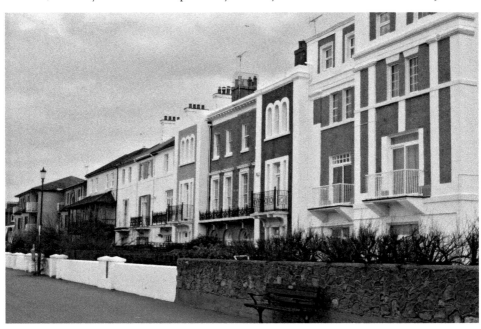

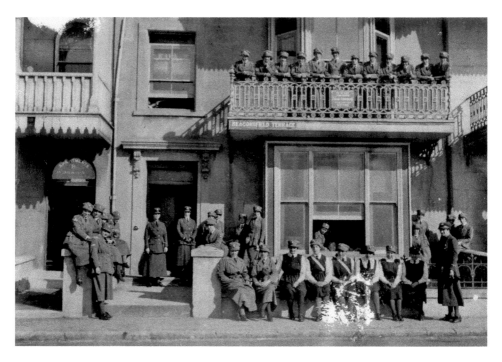

The WRAF in Beaconsfield Terrace

A photograph taken in around 1918 showing the Women's Royal Air Force billeted in one of the houses of Beaconsfield Terrace. The RAF was formed on 1 April 1918 and the aim of its women's section was to train them to take over the work of home-based mechanics. This freed them for service in combat areas. The WRAF was officially disbanded on 1 April 1920. Beaconsfield Terrace today remains little changed from when it was built in the 1880s.

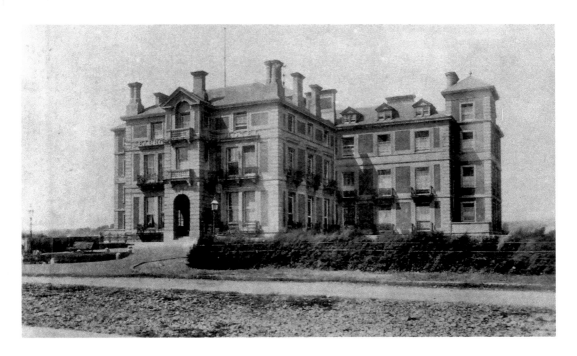

Seabrook Hotel/Hotel Imperial

The Seabrook Hotel was erected by the South Eastern Railway at a cost of £30,000 and was officially opened on 21 July 1880. The hotel was planned as part of the exclusive Seabrook Estate, which was never built, although Princes Parade was opened from the hotel to the Sandgate boundary on 15 October 1881. In 1896, the hotel was enlarged and, five years later, was acquired by the Hythe Imperial Hotel Company, led by William Cobay. The upper photograph shows the hotel in around 1895 and the lower one in 2009.

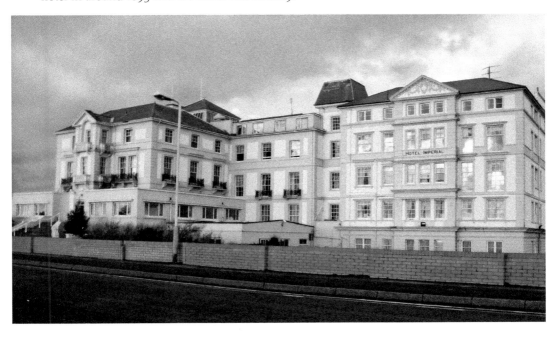

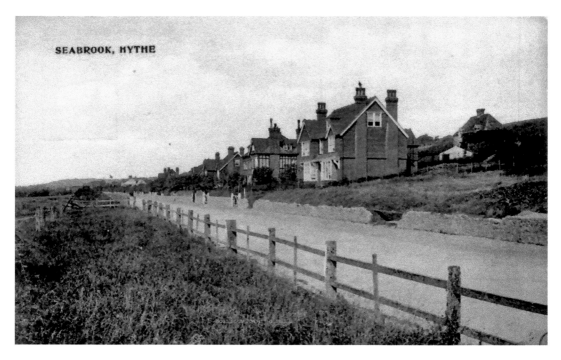

Seabrook Road

A sparsely developed Seabrook end of Seabrook Road photographed by W. S. Paine in 1905. Taken from opposite the Seaview Hotel, the properties on the right are Riversdale, Northenden and Eversleigh. The modern photograph shows that housing has since been built along both sides of what is now the busy A259.

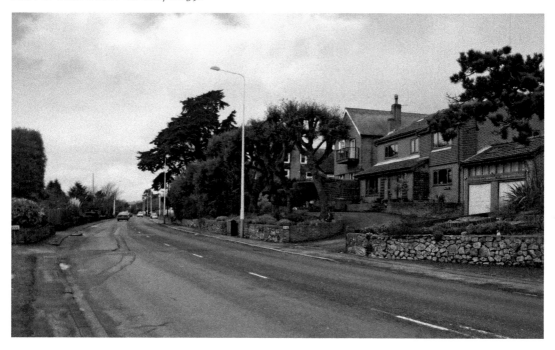

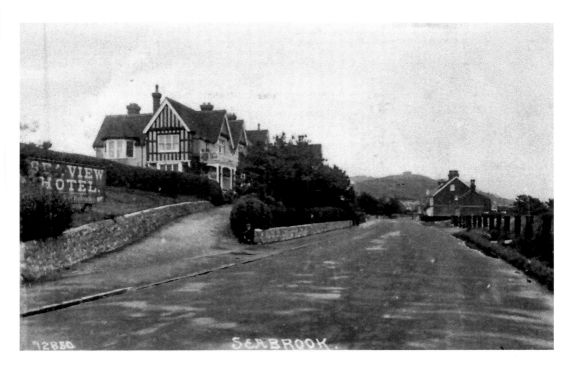

Seaview Hotel

A postcard from around 1910 showing Seabrook Road looking towards Seabrook and on the left the Seaview Hotel. This was erected in 1888-89 and was extended to the east in 1906. In 1961, it was renamed the Seabrook Hotel, but by the mid-1980s had been converted into a restaurant. This was later closed, but in November 1994, the former hotel was reopened as a Christian centre called Cautley House.

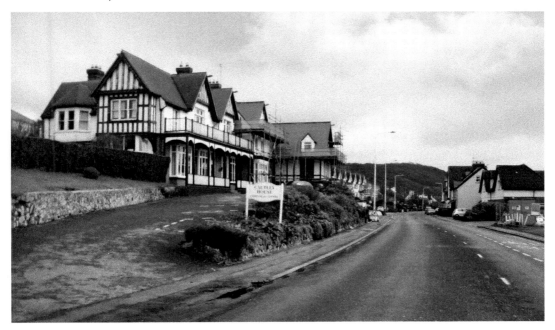

HRH Prince Henry on Seabrook Road

HRH Prince Henry, Duke of Gloucester, passing through Seabrook on 13 July 1927 following a busy schedule in Folkestone. In addition to officially opening the Leas Cliff Hall, the Prince had opened a new wing of the Royal Victoria Hospital and laid the foundation stone of the Harvey Grammar School extension. The houses remain much the same today, although some have had bay windows added.

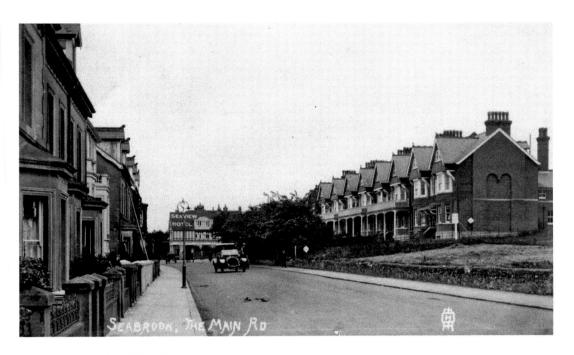

Seabrook Road (Looking West)

Seabrook Road looking towards Hythe, *c.* 1920, with the Seaview Hotel in the distance. The properties on the left were known as 'Benvenue Terrace' and commemorated the famous shipwreck off Sandgate in 1891. John James Jeal, the builder who developed much of Seabrook, lived in one of the villas on the right until his death on 19 June 1920. The vacant space on the far right would be filled in 1929, as the modern photograph shows.

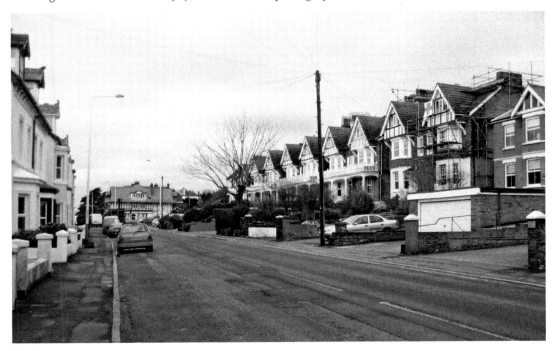

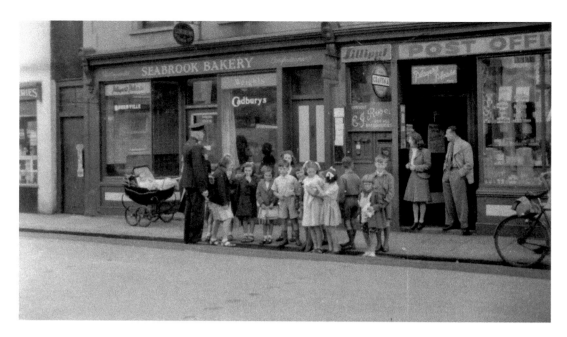

Seabrook Post Office

A delightful scene at Seabrook in the late 1950s showing a group of children ready to cross the road with the assistance of the gentleman in the uniform: note the baby in the period pram outside the bakery. The shops were situated in Plassey Terrace, another row of houses named after a local shipwreck. The lady in the doorway of the post office was Pat Harris, who lived in the area until her death in 2009.

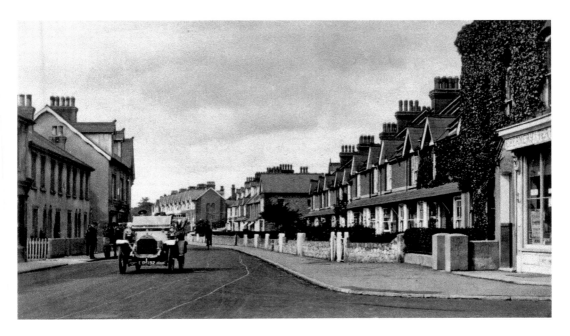

Invicta Terrace, Seabrook

A scene from the 1920s showing a charabanc on its way to Folkestone at the junction of Seabrook Road and Horn Street. Invicta Terrace is the row of twelve properties on the right-hand side. The shop on the corner was the creamery and tearoom of dairyman Walter Young. This later became a VG store, but as the recent photograph shows, it is now a private house.

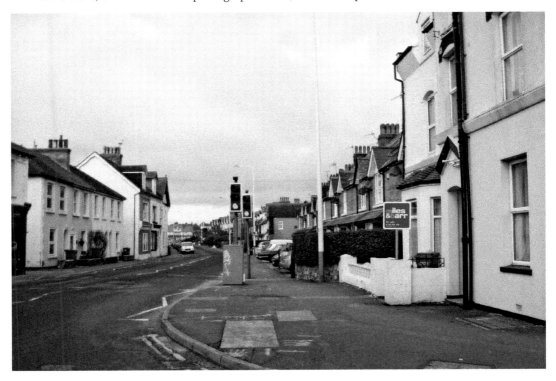

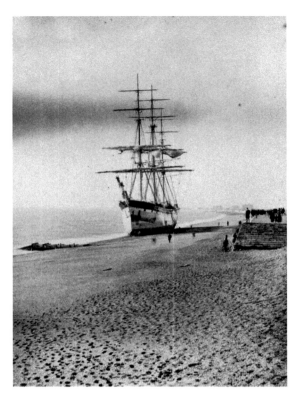

Wreck of the *Plassey*
A before and after view of the stranded iron ship *Plassey*, which came ashore at Seabrook on 29 January 1883. Her crew of sixty, mainly from the Far East, were rescued by the Sandgate coastguard using rocket apparatus. Her cargo of rum and sugar was washed ashore and could be smelt for miles around! The lower photograph shows the sad remains of this once-grand vessel.

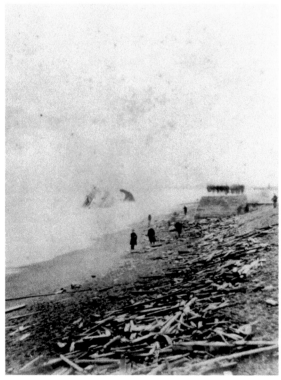

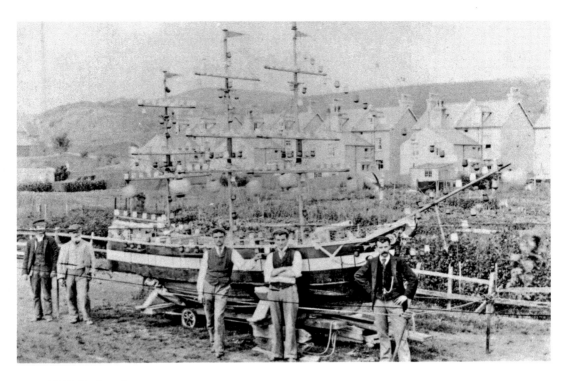

HMS *Seabrook*

This splendid model of a ship, christened 'HMS *Seabrook*', was built for the 1895 Venetian Fête by workmen in J. J. Jeal's builder's yard. Second from the right is Lewis Greenstreet, one of the apprentices. The modern photograph shows that, although the model is long gone, the houses in Seabrook Road still remain.

Beacon Terrace

Fronting the Royal Military Canal at Seabrook, Beacon Terrace was erected in 1906-07 and this postcard shows No. 7 in 1907, newly built. The occupant was Charles Witterick, an agent for the Pearl Assurance Company, although he passed away within a few years and his wife Mary became sole occupant. The terrace remains as built, although No. 7 has been whitewashed and sports a more mature front hedge.

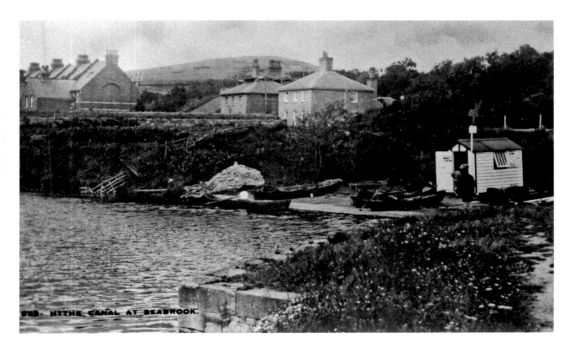

Royal Military Canal, Seabrook

The boat landing stage on the Royal Military Canal at Seabrook, *c.* 1920, where craft were available for hire for a pleasant jaunt up and down the canal. In the background, left to right, are Eastcote Terrace, Station Villa (home of the stationmaster of Sandgate station), and Station Cottages. The boat stage has now gone and Station Villa and Cottages made way for the two rows of 1960s houses.

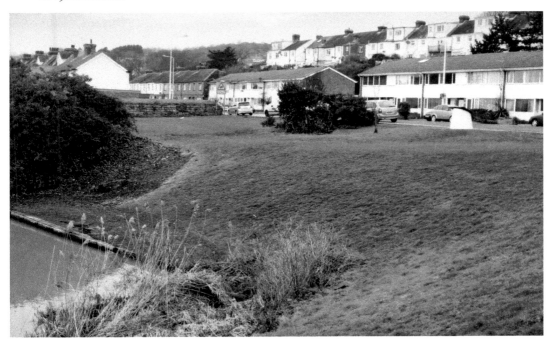

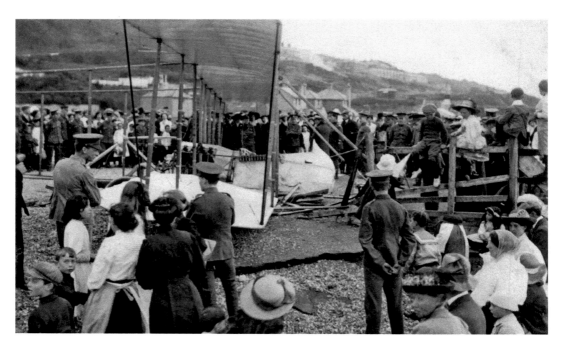

Plane on Seabrook Beach

A postcard by Parson's Library of Hythe showing a crowded scene on Seabrook beach on 13 July 1913 after Lieutenant Ashton had crash-landed his army biplane on a flight from Lydd. The pilot was fortunately unhurt and the wrecked plane was taken back to Lydd the same day. The buildings behind the plane in the picture have been largely replaced by modern housing, including the quite splendid crescent.

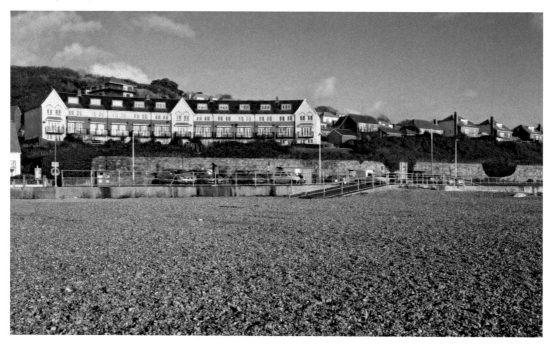

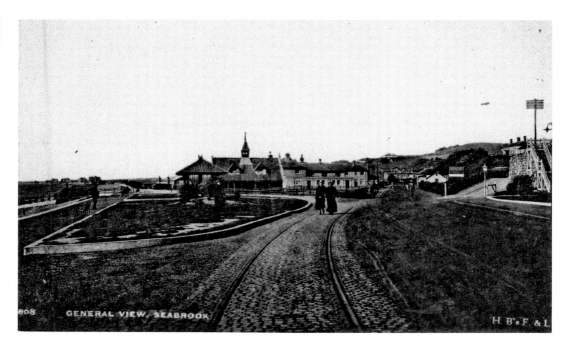

Looking into Seabrook from Sandgate

This unusual H.B. F&L postcard from *c.* 1911 was taken just inside the Sandgate boundary with Seabrook. The photographer is standing on the track of the horse tramway and prominent in the centre of the picture is the old lifeboat station and police station. Up on the hill on the far right is Sandgate station. A car park now covers the site of the small green and tram tracks, and a petrol station has replaced the lifeboat house.

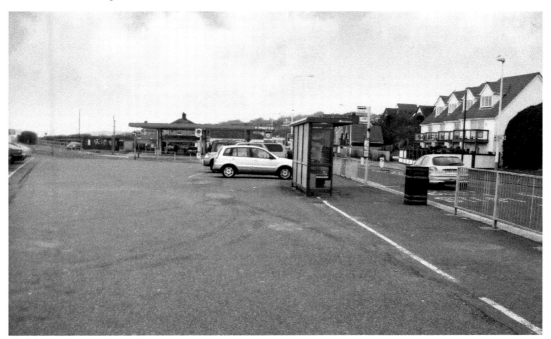

83

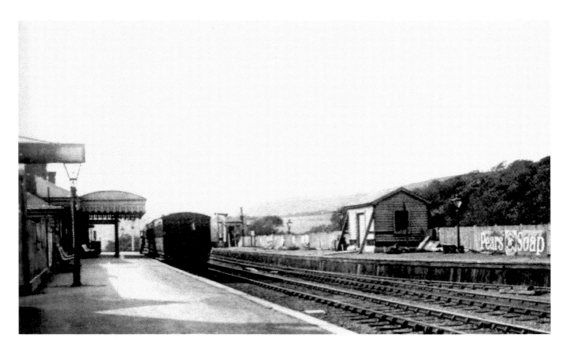

Sandgate Railway Station

Sandgate Station was situated on the Seabrook-Sandgate boundary and is seen here in 1921. The station was the terminus of the South Eastern Railway's Hythe branch from Sandling Junction, which opened on 9 October 1874. An extension to Folkestone Harbour was planned (but not built) which would have led to Sandgate having a station in the centre of the village and this station being renamed Seabrook. The station closed on 1 April 1931 and was used as a bus garage, but its site is now covered in new housing.

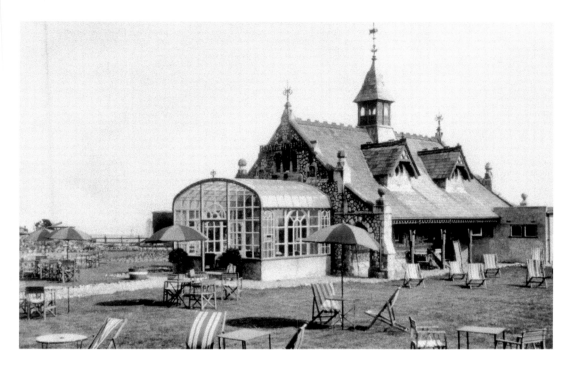

Seabrook Lifeboat Station

The old Seabrook lifeboat station in use as the Boathouse café in the 1930s. This attractive building of Kentish ragstone was erected in 1875 at a cost of £550 to house the Hythe (Seabrook) RNLI lifeboat *Meyer de Rothschild* and remained in use until 1893, when new stations were opened in Hythe (Fishermen's Beach) and Folkestone. The building was immortalised as the 'Goose Cathedral' in Jocelyn Brooke's book of the same name, but was sadly demolished in 1956, and the site is now a petrol station.

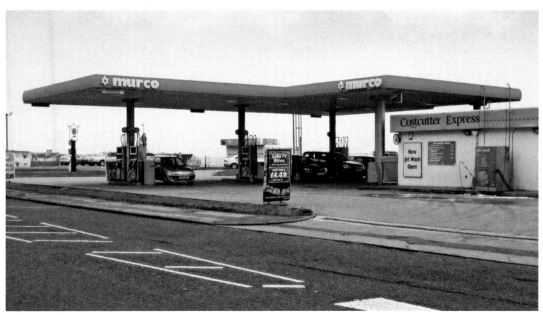

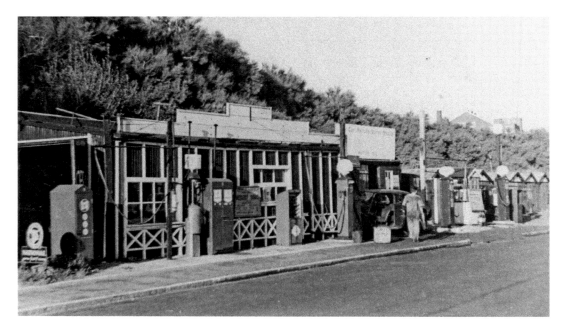

Seabrook Garage

A garage was established at Seabrook on Seabrook Road by Frederick Harlow just after the First World War, with the repair of motorcycles a speciality. In 1923, the garage was remodelled and continued to be run by Harlow for a further ten years until it was acquired by Mrs Hooper. Under her ownership, it became known as the Seabrook Garage before passing to the Hythe Motor Cab Company and then Caffyns. The garage ended is days as a Citroën dealership before it was demolished for new housing, which was completed in 2006.

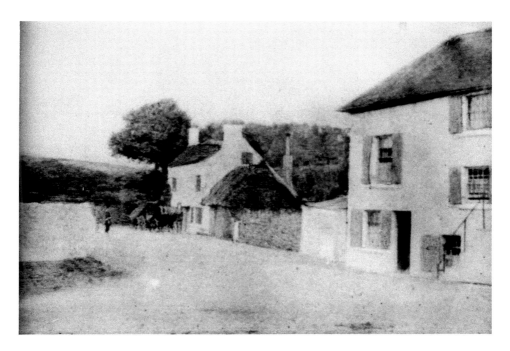

The Original Fountain Hotel

This interesting painting shows the original Fountain Inn and the cottage in Horn Street demolished to make way for the Hythe & Sandgate Railway opened in 1874. The Fountain dates from at least 1841 and this building was demolished in 1887 to make way for the replacement seen in the modern photograph. The railway bridge has not seen a train since the line closed in 1931.

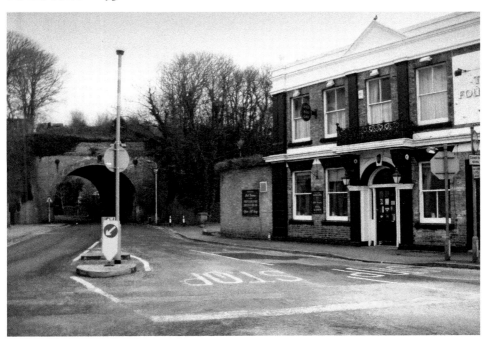

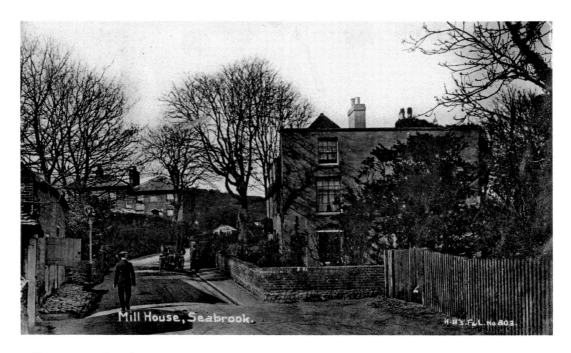

Mill House, Seabrook

A postcard of the Mill House, Seabrook, *c.* 1910, when it was owned by farmer Albert Messenger and let out as a holiday home. The house had lost its mill on 26 March 1859, when it was destroyed by fire. The modern photograph, taken in the snow in February 2010, shows the Mill House still there, but the stables opposite have gone. Seabrook Terrace on the hill remains, as a desirable row of four cottages.

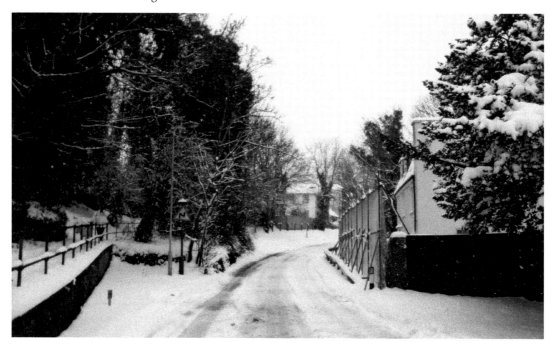

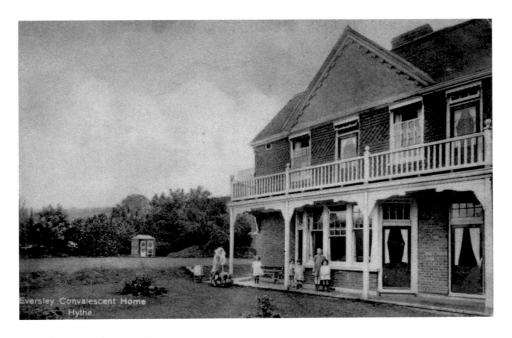

Eversley Convalescent Home

The Eversley Convalescent Home for children was opened on the corner of Horn Street and Spring Lane in 1910. Supported entirely by voluntary contributions, the children were sent to the home from London hospitals to recuperate. The house is now in the hands of the Eastern and Coastal Kent Primary Care Trust and home to the Shepway Community Learning Disability Team, and it can be seen that offices have been added to the original building.

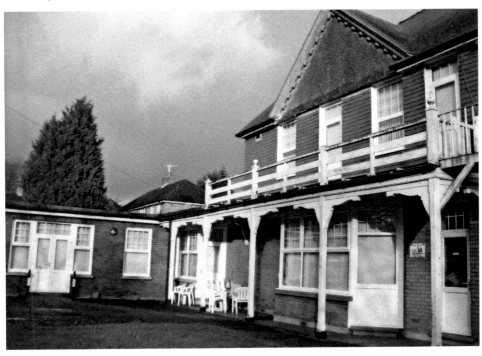

Mrs Mitchell's Shop, Horn Street
A family photograph taken in the 1920s of the Mitchells, who ran a shop in Horn Street in what is now Wisteria Cottage. The shop was opened by sexton George Mitchell in 1910 and, following his death, was run by his wife and then his son, James. The shop closed in 1936 and reverted to a private house, which it remains today.

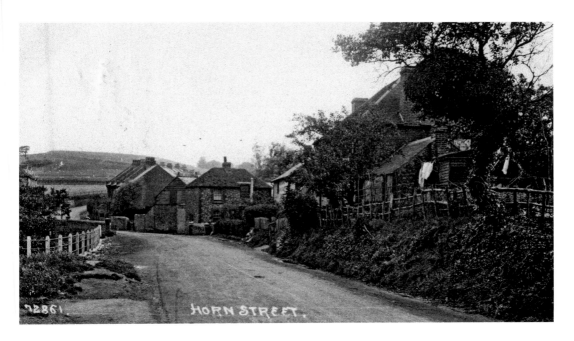

Horn Street

A peaceful scene in the hamlet of Horn Street, which grew around a mill and Britannia Inn, photographed just before the First World War. The Seabrook stream flows just behind the fence on the left. The Britannia Inn was originally two cottages, one of which was licensed to sell beer in 1853. The modern photograph shows that the pub is still trading, but the building in the foreground has been demolished to make way for the entry to Valestone Close.

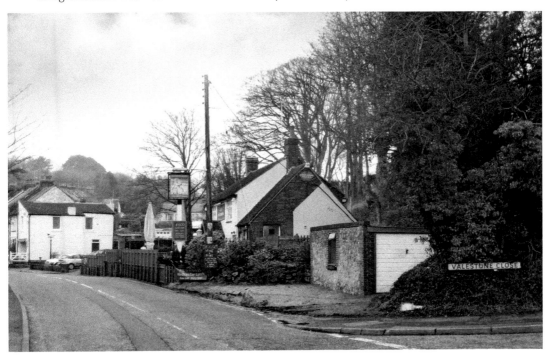

Horn Street Mill (1)

Two views of Horn Street Mill. The top photograph was taken from the south and also shows the mill house and cottages, whilst the lower view shows the northern elevation. The earliest mention of the mill is in 1769, and it boasted the largest water-wheel in Kent (30 feet in diameter), which fed off water from the Seabrook stream diverted into a millpond.

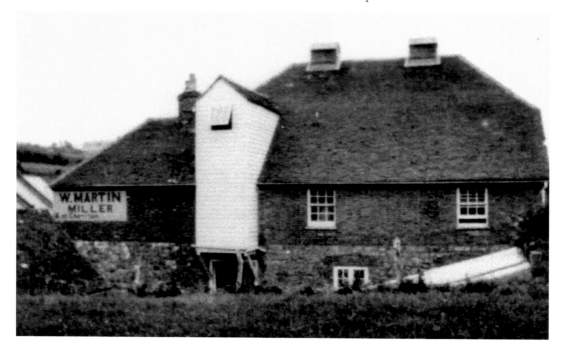

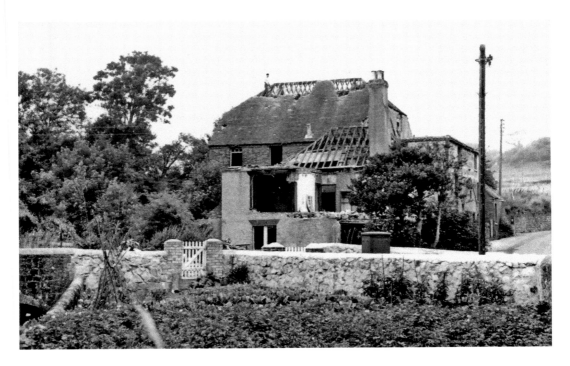

Horn Street Mill (2)

Horn Street Mill under demolition in August 1961. Milling had ceased in 1943, when the cog-wheel attached to the water-wheel broke and could not be replaced. Whilst the demolition was taking place, a fire broke out, speeding up the demolition work. The millers' cottages, however, escaped the demolition and can just be seen on the left of the modern photograph, which shows the housing built on the site of the mill.

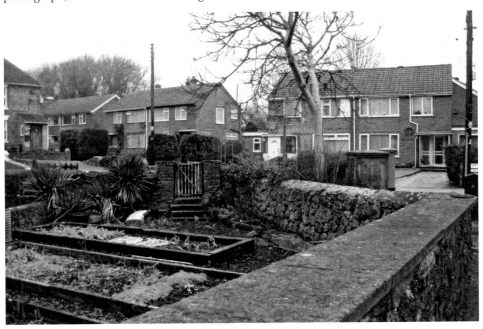

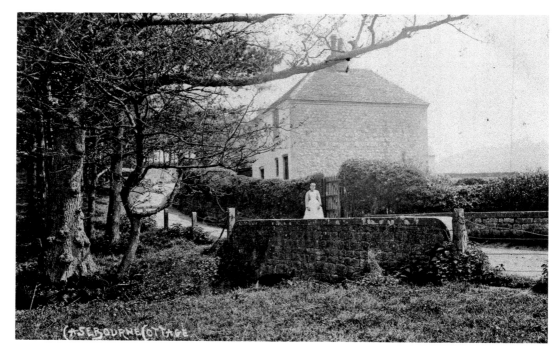

Casebourne Cottage

Situated beyond Horn Street Mill in a lane off Underhill Road is Casebourne Cottage, and this idyllic rural scene of the cottage was taken in 1908 when Charles Ridden was in residence. The little bridge crossed the Seabrook stream meandering through the valley. The cottage survives, but has been altered and enlarged in the past one hundred years.

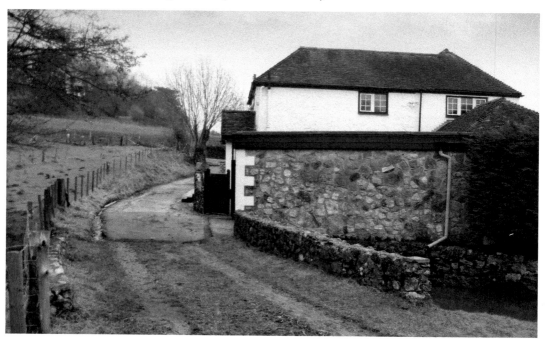

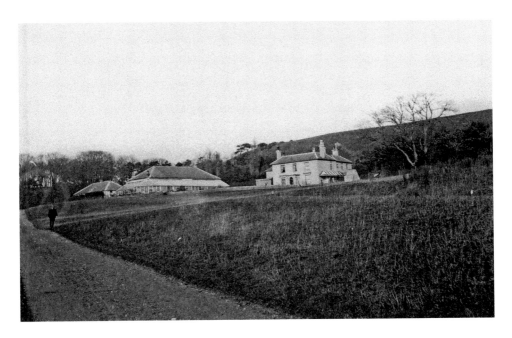

Underhill House

Underhill House, seen here in *c.* 1898, was a handsome villa residence tucked away in isolation in a valley below St Martin's Plain. The house was erected in 1840 and, after being owned by the Brockman family of Beachborough, was used to accommodate the Brigadier of Shorncliffe Camp. However, the house came to acquire a very sinister reputation, due to the suicides and a 1934 murder that took place there, and became known as one of England's most haunted houses. The house was destroyed by fire in 1978 (although a barn still stands and can be seen in the photograph below), but the ghostly happenings are said to occur still.

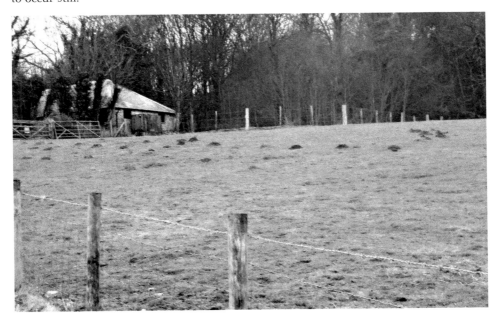

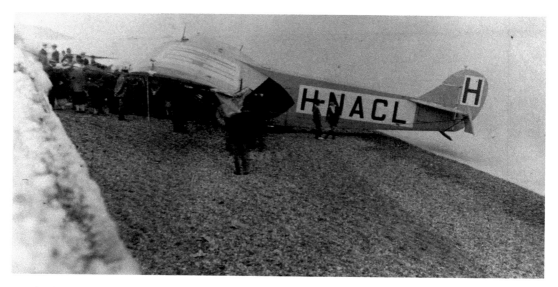

Crashed Aircraft on Seabrook Beach

On 21 June 1926, a Dutch Mail monoplane was flying from Rotterdam to Croydon with four passengers on board when the engine cut out and the pilot managed to make a safe landing on Seabrook beach. Fortunately, there were no injuries amongst the passengers, although a local fisherman gained a badly cut leg after being struck by one of the wings. The plane was soon removed and lived to fly another day.

Acknowledgements

The authors would sincerely like to thank the following for their assistance in the preparation of this book: Peter and Annie Bamford, Peter Carter, John and Laura Cobb, Patricia Herbert, Peter Hooper, Mike Lilley, George and Bridget Newman, Alan F. Taylor, Rachel Watts, Vince Williams, Folkestone Library, Hythe Library.